BIG TYPE

Y

INCLUDING OVER 200 EXAMPLES OF WORK WITH DESIGNERS' COMMENTS AND ANALYSIS

BIG TYPE

GENERAL EDITOR: ROGER WALTON

BIG TYPE

First published in 2002 by:
HBI, an imprint of HarperCollins*Publishers*
10 East 53rd Street
New York, NY 10022-5299
United States of America

Distributed in the United States
and Canada by:
North Light Books, an imprint of
F & W Publications, Inc.
4700 East Galbraith Road
Cincinnati, Ohio 45236
1-800-289-0963

Distributed throughout the rest
of the world by:
HarperCollins International
10 East 53rd Street
New York, NY 10022-5299
Fax: (212) 207-7654

ISBN: 0-06-018581-3

Conceived, created, and designed by:
Duncan Baird Publishers
6th Floor, Castle House
75–76 Wells Street, London W1T 3QH

Designers: Rebecca Johns and Paul Reid at Cobalt id
Editor: Marek Walisiewicz at Cobalt id
Project Co-ordinator: Tamsin Wilson

10 9 8 7 6 5 4 3 2 1

Typeset in Meta Plus
Color reproduction by Scanhouse, Malaysia
Manufactured in China

NOTE
All measurements listed in this book
are for width followed by height.

CONTENTS

Big Type is not what it might seem. This book is a collection of design work in which the typographic elements assume primary importance. The type itself is not always big; in fact, the book demonstrates that TINY type can often shout far louder than the largest characters. *Big Type* is an essential source book of typographic inspiration. It contains some of the most provocative, brazen, subtle, and inspired work from design studios and colleges around the world. And in celebrating the diversity of design intelligence, it confirms the undiminished power of typography in the digital age.

Typographic communication is so ubiquitous that it passes – for most of us – unnoticed. Not so for the graphic designer, for whom every appearance of type in daily life – on a bus ticket, in a magazine, or on the titles of a television show – carries meaning and conveys mood. This collection of work presents a varied sample of the many and diverse ways in which type can be made to communicate; type made from strips of cut fabric, machined from metal, and projected onto cityscapes, sits alongside classic letterpress typography and formal arrangements for sober-suited corporate clients, but every page of this book shows that truly perceptive typography will always underline and illuminate the meaning of the text it carries. So, for enjoyment and creative inspiration, simply explore the pages of *Big Type* and believe in the power of typography.

THE

A B C D E F G H I J K L M N
O P Q R S T U V W X Y Z a b
c d e f g h i j k l m n o p q r
s t u v w x y z 1 2 3 4 5 6 7
7 8 9 0 ! & ? : ; " "

WORK

26. 04. 2002 SIGN KOMMUNIKATION UND E15 LADEN EIN.
17.00 BIS 20.00 UHR BOOK RELEASE. SIGN: ON THE INSIDE/ IN THE OUTSIDE, VERLAG HERMANN SCHMIDT MAINZ, BEI BE
AB 19.00 UHR FEIERN SIE MIT UNS IN DEN NEUEN RÄUMEN VON SIGN. GEPLANT UND EINGERICHTET VON E15. OSKAR-V

E15 and sign: invitation and promotional book (see also pp. 12–13)
The miniature logos of these two companies – furniture and graphic designers
– make up the background texture of an invitation to the launch of a book
jointly produced by the two. The book itself (see over) maintains and builds
on this style. Headline type is set with no space between the lines, and all
other text is set justified and in capitals: this creates strong blocks of type
that mirror the strong geometric shapes of the furniture.

MAN, KAISERSTR. 23, 60311 FRANKFURT AM MAIN
MILLER-STR. 14, 60325 FRANKFURT AM MAIN

Designer
Antonia Henschel

Art director
Antonia Henschel

Design company
SIGN Kommunikation

Country of origin
Germany

Description of artwork
Invitation (left) and
book (over)

Dimensions
Invitation
$11^1/_2$ x $8^1/_4$ in
297 x 210 mm
Book
$6^1/_2$ x $9^1/_2$ in
170 x 240 mm

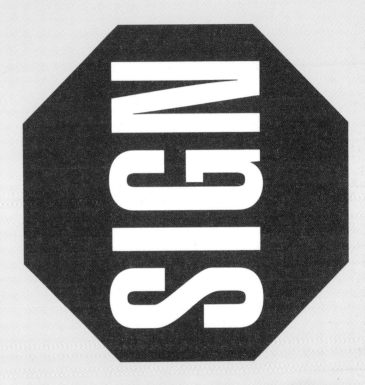

TO BE REALLY RICH, IS TO
HAVE ONE'S SPACE.
A BIG EMPTY
SPACE

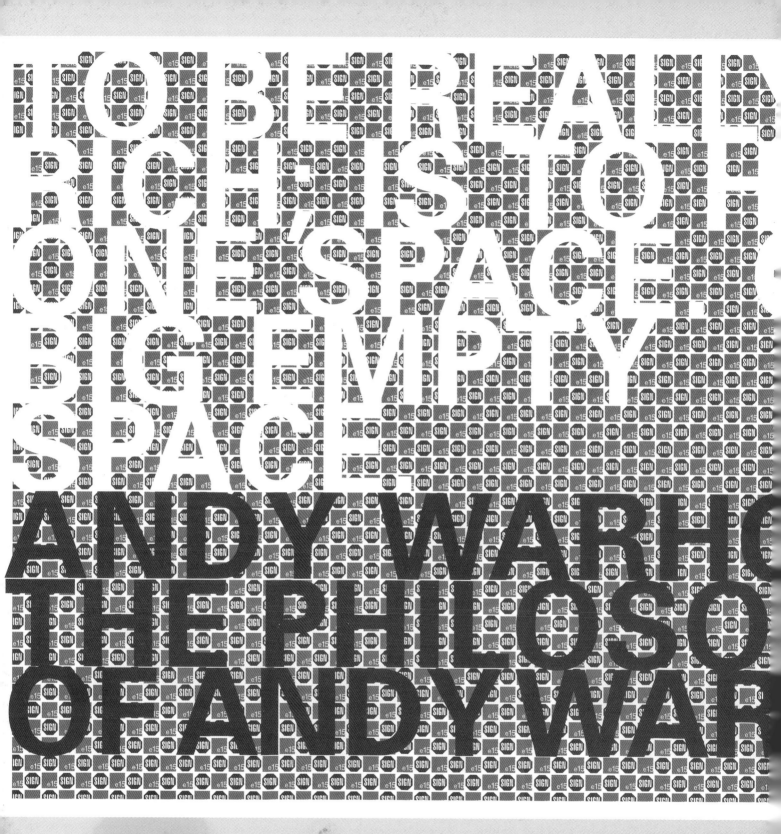

ANDY WARHOL
THE PHILOSO
OF ANDY WAR

SIGN AND E15 INVITE YOU

WE HAVE MORE THAN ONE GOOD REASON:

SIGN HAS MOVED. OUR NEW HOME IN OSKAR-VON-MILLER STRASSE IN FRANKFURT AM MAIN IS FAR MORE TO US THAN JUST A NEW WORK PLACE. IT IS OUR LIVING SPACE. IT IS WHERE WE FEEL AT HOME AND IT IS WHERE OUR INSPIRATION TAKES SHAPE.

SIGN AND E15 - TOGETHER WITH YOU - WANT TO RAISE OUR GLASSES TO A SYNERGETIC CO-OPERATION. SIGN PRODUCES GRAPHIC DESIGN FOR E15. E15 LOOKED AFTER THE INTERIOR ARCHITECTURE OF THE NEW SIGN PREMISES, THE DESIGN OF WHICH CAME FROM THE ARCHITECT PHILIPP MAINZER.

SIGN IS TURNING 30. 30 YEARS ON WHICH WE CAN LOOK BACK, IN WHICH WE HAVE BEEN ABLE TO DEVELOP FURTHER, YEAR FOR YEAR, AND IN WHICH WE HAVE FOUND OUR VERY OWN STYLE OF COMMUNICATION.

LAST BUT NOT LEAST, ALL OF THIS CAN BE SEEN AND READ ABOUT IN 'ON THE INSIDE/ IN THE OUTSIDE'. THE NEW SIGN TWIN BOOKS AVAILABLE FROM PUBLISHERS HERMANN SCHMIDT MAINZ AND SELECTED BOOKSTORES. ISBN 3-87439-504-9

SIGN UND E15 LADEN EIN

GUTE GRÜNDE HABEN WIR MEHR ALS EINEN:

SIGN IST UMGEZOGEN. UNSER NEUES DOMIZIL IN DER OSKAR-VON-MILLER-STRASSE IN FRANKFURT AM MAIN IST FÜR UNS WEIT MEHR ALS NUR ARBEITSRAUM. ES IST UNS LEBENSRAUM, WOHLFÜHLRAUM UND IMMER WIEDER AUCH-RAUM DER INSPIRATION.

SIGN UND E15 WOLLEN - GEMEINSAM MIT IHNEN - AUF DIE FRÜCHTE IHRER SYNERGETISCHEN ZUSAMMENARBEIT ANSTOSSEN. SIGN MACHT GRAFIK-DESIGN FÜR E15. E15 RICHTETE DIE NEUEN SIGN-RÄUME EIN, DEREN ENTWURF WIEDERUM VON ARCHITEKT PHILLIP MAINZER STAMMT.

SIGN WIRD 30. 30 JAHRE, AUF DIE WIR GERNE ZURÜCKBLICKEN, IN DENEN WIR UNS JAHR FÜR JAHR WEITERENTWICKELN KONNTEN. UND SCHLIESS-LICH UNSEREN EIGENEN KOMMUNIKATIONSSTIL GEFUNDEN HABEN.

LAST BUT NOT LEAST IST ALL DAS NACH ZU SCHAUEN - UND ZU LESEN - IN 'ON THE INSIDE/ IN THE OUTSIDE'. DEN NEUEN SIGN-ZWILLINGS-BÜCHERN. ERHÄLTLICH BEIM VERLAG HERMANN SCHMIDT MAINZ UND AUSGEWÄHLTEN BUCHHANDLUNGEN. ISBN 3-87439-504-9

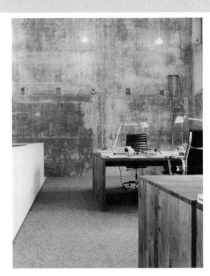

FRANKFURTER KÜCHE

THOMAS MARKOVIC KOCHT FÜR SIGN KOMMUNIKATION. DAS FEST ZU IHREM 30-JÄHRIGEN GEBURTSTAG FEIERT DIE FRANKFURTER DESIGN-INSTITUTION STILECHT MIT KLASSISCHEN FRANKFURTER GAUMEN-FREUDEN. ZUBEREITET VOM 'KLASSISCHEN' KOCH-KÜNSTLER THOMAS MARKOVIC, DER SEIT 3 JAHREN AUCH DIE 'BETRIEBSKANTINE' DER EHEMALIGEN FABRIK IN DER CASSELLASTRASSE 30/32 ALS KUNST-PROJEKT BETREIBT.

UNTER FRANKFURTER WERBERN, KULTURSCHAFFENDEN, FRANZÖSI-SCHEN KONSULN, PATHOLOGEN UND ANDEREN VERRÜCKTEN IST MARKOVIC BEKOCHT. EVENTS, MESSEN, FILMPRODUKTIONEN, HOCH-ZEITEN UND TODESFÄLLE GENAUSO WIE ROMANTISCHE ONE-TO-ONE-DINNERS. UNTER PHANTASIEVOLLEN CLAIMS FÜHRT ER SEINE GÄSTE 'IN 80 ESSEN UM DIE WELT' UND 'RUND UMS MITTELMEER'. VERFÜHRT SIE MIT 'NIEDERRHEIN BROTEN' - EINER HOMMAGE AN DIE 70ER - GANZ WONACH ES SEINE AUFTRAGGEBER GELÜSTET.

WIE DER APPLE ZUM KREATIVEN, GEHÖRT DER APFEL ZUM ECHTEN FRANKFURTER MENÜ - UND ZWAR NICHT NUR IN FLÜSSIGER FORM: MAINSCHIFFER-LACHSSALAT ODER MAIN WAR VOR DER INDUSTRIALI-SIERUNG EIN LACHSREVIER UND SOLL WIEDER EINES WERDEN), APPLE CRUMBLE, SCHNEEGESTÖBER, GRÜNE SOßE UND SECKBACHER BLUMEN-KOHL SIND NUR EINIGE DER LECKERBISSEN, DIE AUCH DIE AUSWÄRTIGEN GÄSTE VON SIGN AM MAIN SOFORT FÜR SICH EINNEHMEN WERDEN.

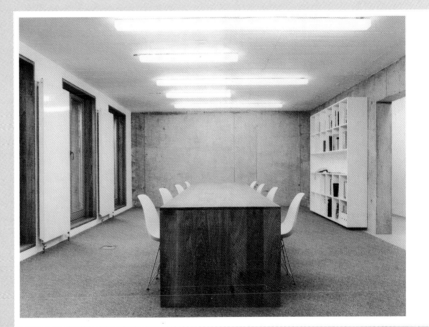

MEHR UNTER:
WWW.SIGN.DE
WWW.E15.COM

LA FREEWAVES PRESENTS ITS TENTH ANNIVERSARY PROJECT: TV OR NOT TV

> 3 HALF-HOUR PROGRAMS OF ARTIST INTERVIEWS AND EXCERPTS
> 1-HOUR COMPILATION OF SHORT ART VIDEOS
> CURRICULUM GUIDE

< MEDIA ARTS IN LOS ANGELES >

tv or not tv: coursebook
LA Freewaves is a media arts network that encourages artistic and social expression. This book serves as a guide to learning about digital media projects. The typeface used for headings, the graphic devices employed throughout, and the treatment of images, are all reminiscent of early digital displays and the trappings of film technology, while the contrasting traditional text font maximizes legibility on paper.

<001>

VOICES UNHEARD

Summary of Program

Voices Unheard expands our understanding of the television medium through dialogues with independent video artist in Los Angeles. In a city better known as a purveyor of dreams, these artists have, in their own way, used the video camera as a tool to explore personal realms outside Hollywood's paradigms. In an age where visual literacy is as important as reading and writing, these artists are redefining the language of video. Whether they use the camera to explore pop culture or to look within themselves, they tell us not only what television is, but what it could be.

Curriculum by Susan Boyle
Susan Boyle is a media studies and English teacher at Roosevelt High School.

29

RUNNING TIME 00:05:00

KAOS

BEN CALDWELL

Includes excerpts from performances and animated works created by teens at KAOS Network.

Ben Caldwell, the creative force behind KAOS Network, has more than 20 years experience as a producer, director, editor, writer and teacher in the theatrical, documentary and television fields. KAOS Network has, since its founding in 1984, opened its doors to young people, creating a community of dedicated artists who are eager to learn new technologies and acquire employable skills. Each week, more than 150 entrepreneurs participate in workshops and programs in video, animation, digital arts, video teleconferencing, artist development, and drop-in performance/open mike programs.

This segment highlights activities at KAOS Network.

Designer
Brad Bartlett

Art director
Brad Bartlett

Design company
Turnstyle Design

Country of origin
USA

Description of artwork
Book to accompany an educational video series "TV or Not TV"

Dimensions
5³/₄ x 8¹/₂ in
145 x 215 mm

73

TV

GENERAL PRINCIPLES IN MEDIA LITERACY

WE KNOW ABOUT THE WORLD PRIMARILY FROM THE MEDIA. BUT THE MEDIA DON'T SIMPLY GIVE US THE WORLD. THEY INTERPRET REALITY, TAILOR IT, PERFORM IT. IN ORDER TO BE RESPONSIBLE CITIZENS, WE NEED TO BE MEDIA LITERATE. TO HELP YOU ENGAGE IN THAT PROCESS, HERE ARE EIGHT "KEY CONCEPTS" OF MEDIA LITERACY.

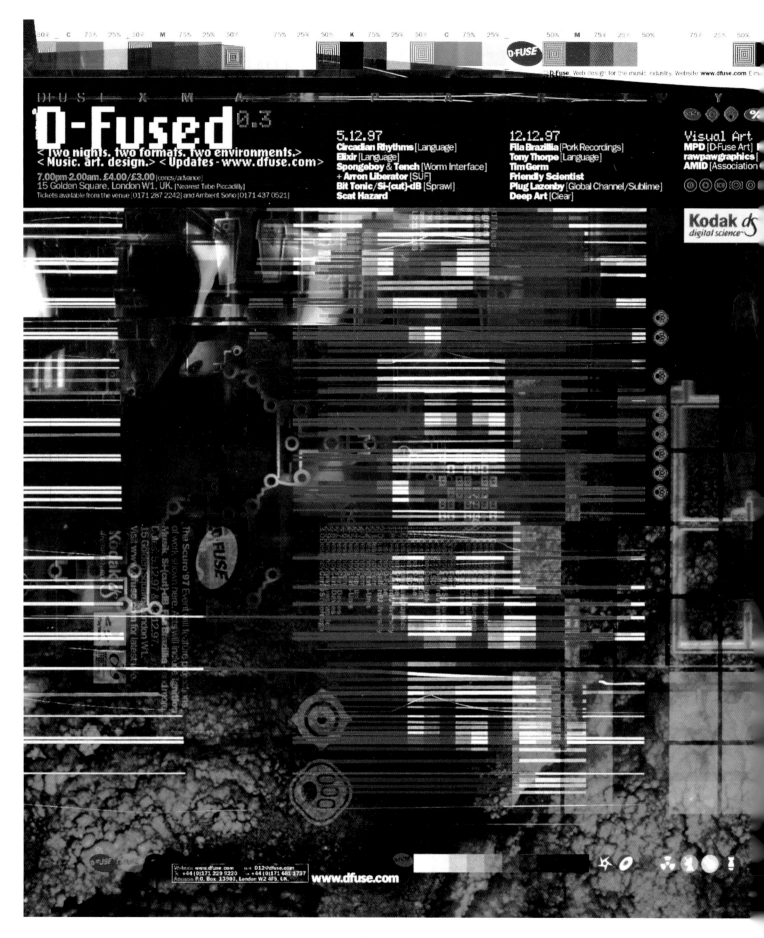

D-Fused 0.3

< Two nights. two formats. two environments.>
< Music. art. design.> <Updates - www.dfuse.com>

7.00pm-2.00am. £4.00/£3.00 [concs/advance]
15 Golden Square, London W1, UK. [Nearest Tube Piccadilly]
Tickets available from the venue [0171 287 2242] and Ambient Soho [0171 437 0521]

5.12.97
Circadian Rhythms [Language]
Elixir [Language]
Spongeboy & **Tench** [Worm Interface]
+ Arron Liberator [SUF]
Bit Tonic/Si-(cut)-dB [Sprawl]
Scat Hazard

12.12.97
Fila Brazillia [Pork Recordings]
Tony Thorpe [Language]
Tim Germ
Friendly Scientist
Plug Lazonby [Global Channel/Sublime]
Deep Art [Clear]

Visual Art
MPD [D-Fuse Art]
rawpawgraphics [
AMID [Association

Kodak ds
digital science

Website: www.dfuse.com D12@dfuse.com
+44 [0]171 229 9220 +44 [0]171 681 1737
Address P.O. Box 13303, London W2 4FS, UK.

www.dfuse.com

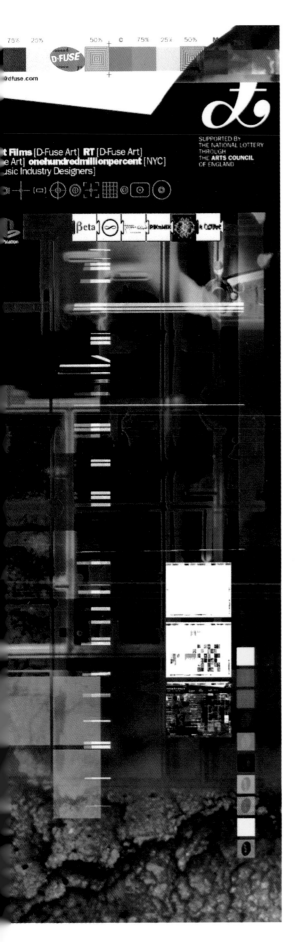

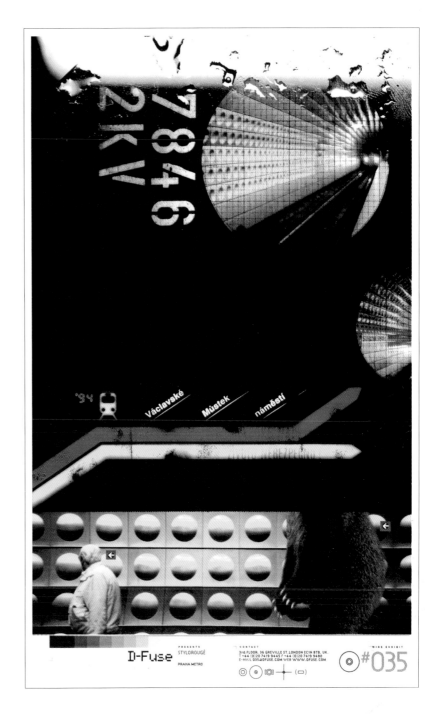

the wire space: magazine page design (see also pp. 18–19)

Modern music magazine *The Wire* commissioned design company D-Fuse to regularly produce a page of graphic art for use in the magazine. In turn, D-Fuse opened the "Wire space" to other artists: the five pieces here showcase the great variety of work generated by this bold approach to publishing.

Designers
D-Fuse, Stylo Rougé, Eric Zimm, Curator of the Institute of Spoons, N.I.C.J.O.B.

Art director
Michael Faulkner

Design company
D-Fuse

Country of origin
Various

Description of artwork
Magazine page

Dimensions
9 x 10³/₄ in
230 x 278 mm

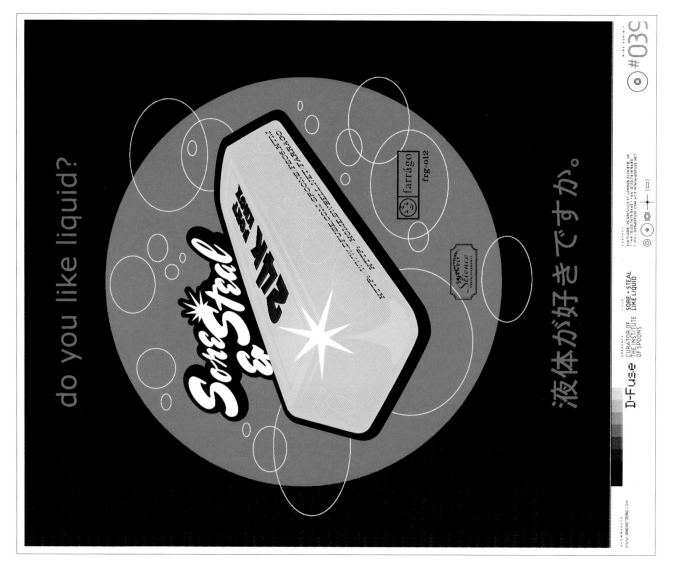

do you like liquid?

液体が好きですか。

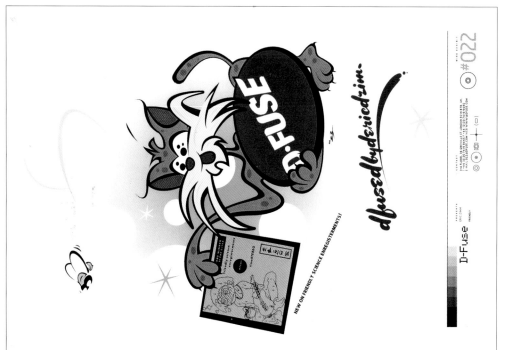

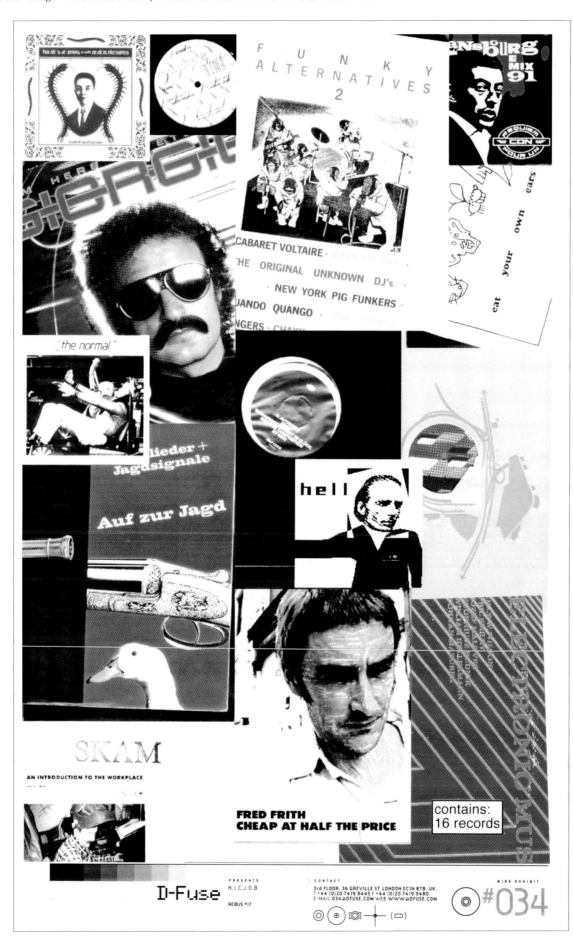

FUNKY ALTERNATIVES 2

CABARET VOLTAIRE ·
THE ORIGINAL UNKNOWN DJ's
· NEW YORK PIG FUNKERS ·
QUANDO QUANGO ·
NGERS · CHAK

eat your own ears

"the normal"

lieder + Jagdsignale

Auf zur Jagd

hell

SKAM

AN INTRODUCTION TO THE WORKPLACE

FRED FRITH
CHEAP AT HALF THE PRICE

contains:
16 records

D-Fuse

PRESENTS
N.I.C.J.O.B

REBUS #17

CONTACT
3rd FLOOR. 36 GREVILLE ST. LONDON EC1N 8TB. UK.
T +44 (0)20 7419 9445 F +44 (0)20 7419 9480
E-MAIL 034 @DFUSE.COM WEB WWW.@DFUSE.COM

WIRE EXHIBIT

#034

19

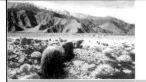

DESI

Rem

the

imp

tem

120

Fre

tri

bef

cor

sor

THE

CHOLLA SANS ITALIC

CHOLLA SANS BOLD

CHOLLA SANS THIN

CHOLLA WIDE

CHOLLA WIDE SMALL CAPS

CHOLLA SLAB REGULAR

CHOLLA SLAB OBLIQUE

CHOLLA SLAB BOLD

CHOLLA SLAB THIN

CHOLLA UNICASE

CHOLLA UNICASE LIGATURES

A Trip Out West

A Type Specimen introducing the Typeface Family

Cholla

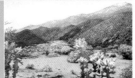

cholla typeface: type specimen booklet

The typeface "Cholla", originally designed for the Art Center College in Pasadena, California, is named for a type of cactus that grows in the Mojave desert. This booklet, which displays samples of the entire font family, takes the form of a travelog through the desert, subtly showcasing the different personalities of the 12 different cuts of the typeface.

RT WARNINGS

ember when t

climate plays

rtant role in yo

perature ma

F AND ALSO I

zing. Plan

very caref

re ventur

rasting wild

ETHING HAPP

ʰIGH GROUND

Designer
Sibylle Hagmann

Art director
Sibylle Hagmann

Design company
Kontour design

Country of origin
USA

Description of artwork
Booklet

Dimensions
6¹/₂ x 9¹/₂ in
165 x 241 mm

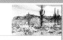

the Country of Lost Borders.

From June on to November it lies hot, still, and unbearable, sick with violent **unrelieving storms;** then on until April, chill, quiescent, drinking its scant rain and scanter snows; from April to the **hot season** again, blossoming, radiant, and seductive. These months are only approximate; later or earlier the rain-laden wind may drift up the water gate of the Colorado from the Gulf, and **the land sets its seasons by the rain.**

Ute, Paiute, Mojave, and Shoshone inhabit its frontiers, and as far into the heart of it as a man dare go. Not the law, but the land sets the limit. Desert is the name it wears upon the maps, but the Indian's is the better word. Desert is a loose term to indicate land that supports no man; whether the land can be bitted and broken to that purpose is not proven. Void of life it never is, however dry the air and villainous the soil.

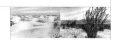

CHOLLA SANS REGULAR
ABCDEFGHIJKLMNOPQRSTUVWXYZabcdefghijklmnopqrstu
vwxyzfifiβæœÀÁÂÃÄÅÀÇÈÉÊËÌÍÎÏÑÒÓÔÕÖÙÚÛÜŸàáâãäåçèéê
ëíìîïñòóôõöùúûüÿ0123456789{[[*/.....:;?!!§$¢£¥€%‰++=]|¶§†‡ÆŒ

CHOLLA SANS ITALIC

The hill surface is streaked with ash drift and black, unweathered lava.

aAₐAaAAaA

CHOLLA SANS BOLD
ABCDEFGHIJKLMNOPQRSTUVWXYZabcdefghijklmnopqrs
tuvwxyzfifiβæœÀÁÂÃÄÅÀÇÈÉÊËÌÍÎÏÑÒÓÔÕÖÙÚÛÜŸàáâãäå
çèéêëíìîïñòóôõöùúûüÿ0123456789{[[*/.....:;?!!§$¢£¥€%‰++=]
|¶§†‡ÆŒ☞☜☟☛TMBO☝#_\~~⌐⌐═⌐═]}}

CHOLLA SANS ITALIC
ABCDEFGHIJKLMNOPQRSTUVWXYZabcdefghijklmnopqrst
vwxyzfifiβæœÀÁÂÃÄÅÀÇÈÉÊËÌÍÎÏÑÒÓÔÕÖÙÚÛÜŸàáâãäåçèéê
ëíìîïñòóôõöùúûüÿ0123456789{[[*/.....:;?!!§$¢£¥€%‰++=]|¶§†‡
ÆŒ☞☜☟☛TMBO☝#_\~~⌐⌐═⌐═]}}

The desert floras shame us with their cheerful adaptations to the seasonal limitations. Their whole duty is to flower and fruit, and they do it hardly, or with tropical luxuriance, as the rain admits. It is recorded in the report of the Death Valley expedition that after a year of abundant rains, on the Colorado desert was found a specimen of Amaranthus ten feet high. A year later the same species in the same place matured in the drought at four inches. One hopes the land may breed like qualities in her human offspring, not fritely to "try," but to do. Seldom does the desert herb attain the full stature of the type. Extreme aridity and extreme altitude have the same dwarfing effect, so that we find in the high Sierras and in Death Valley related species in miniature that reach a comely growth in mean temperatures.

CHOLLA WIDE 10/16 PT
Very fertile are the desert plants in expedients to prevent evaporation, turning their foliage edgewise toward the sun, growing silky hairs, exuding viscid gum. The wind, which has a long sweep, harries and helps them. It rolls up dunes about the stocky stems, encompassing and protective, and above the dunes, which may be, as with the mesquite, three times as high as a man, the blossoming twigs flourish and bear fruit. There are many areas in the desert where drinkable water lies within a few feet of the surface, indicated by the mesquite and bunch grass (Sporobolus airoides). It is this nearness of unimagined help that makes the tragedy of desert deaths. It is related that the final breakdown of that hapless party that gave Death Valley its forbidding name occurred in a locality where shallow wells would have saved them.
But how were they to know that?

CHOLLA WIDE SMALL CAPS AND UNICASE LIGATURES 20/16 PT

ALONG SPRINGS AND SUNKEN WATERCOURSES ONE IS SURPRISED TO FIND SUCH WATER-LOVING PLANTS AS GROW WIDELY IN MOIST GROUND, BUT THE TRUE DESERT BREEDS ITS OWN KIND, EACH IN ITS PARTICULAR HABITAT.

CHOLLA WIDE
ABCDEFGHIJKLMNOPQRSTUVWXYZabcdefghijklmno
pqrstuvwxyzfifiβæœÀÁÂÃÄÅÀÇÈÉÊËÌÍÎÏÑÒÓÔÕÖÙÚ
ÛŸàáâãäåçèéêëíìîïñòóôõöùúûüÿ0123456789{[[*/
.....:;?!!§$¢£¥€%‰++=]|¶§†‡ÆŒ☞☜☟☛TMBO☝#_

CHOLLA WIDE SMALL CAPS
ABCDEFGHIJKLMNOPQRSTUVWXYZabcdefghijklmno
pqrstuvwxyzfifiβæœÀÁÂÃÄÅÀÇÈÉÊËÌÍÎÏÑÒÓÔÕÖÙÚ
ÛŸàáâãäåçèéêëíìîïñòóôõöùúûüÿ0123456789{[[*/
.....:;?!!§$¢£¥€%‰++=]|¶§†‡ÆŒ☞☜

aAAaAaaA

CHOLLA UNICASE
ABCDEFGHIJKLMNOPQRSTUVWXYZabcdefghijklmn
opqrstuvwxyzfifiβæœÀÁÂÃÄÅÀÇÈÉÊËÌÍÎÏÑÒÓÔÕÖ
ùúûüÿàáâãäåçèéêëíìîïñòóôõöùúûüÿ0123
456789{[[*/.....:;?!!§$¢£¥€%‰++=]|¶§†‡ÆŒ☞☜#_

CHOLLA UNICASE LIGATURES
ABCDEFGHIJKLMNOPQRSTUVWXYZabcdefghijklmn
opqrstuvwxyzfifiβæœ☞☜☟☛gfaↄↄcfyↄↄↄↄↄↄↄↄↄↄ
etↄↄtfↄↄↄↄↄↄↄↄↄↄↄↄↄↄↄↄↄↄↄↄↄↄↄↄↄↄ
hↄↄↄↄↄↄↄↄ0123456789{[[*/.....:;?!!§$¢£¥€%‰++

CHOLLA UNICASE 21/22 PT
properly equipped it is possible to go safely across that ghastly sink, yet every year it takes its toll of death, and yet men find there sun-dried mummies, of whom no trace or recollection is preserved. to underestimate one's thirst, to pass a given landmark to the right or left, to find a dry spring where one looked for running water—there is no help for any of these things.

CHOLLA SLAB THIN, BOLD, REGULAR 10/13 PT
The angle of the slope, the frontage of a hill, the structure of the soil determines the plant. South-looking hills are nearly bare, and the lower tree-line higher here by a thousand feet. Cañons running east and west will have one wall naked and one clothed. **Around dry lakes and marshes the herbage preserves a set and orderly arrangement. Most species have well-defined areas of growth, the best index the voiceless land can give the traveler of his whereabouts.** If you have any doubt about it, know that the desert begins with the creosote. This immortal shrub spreads down into Death Valley and up to the lower timber-line, odorous and medicinal as you might guess from the name, wandlike, with shining fretted foliage. Its vivid green is grateful to the eye in a wilderness of gray and greenish white shrubs. On the spring it exudes a resinous gum which the Indians of those parts know how to use with pulverized rock for cementing arrow points to shafts. Trust Indians not to miss any virtues of the plant world! Nothing the desert produces expresses it better than the unhappy growth of the tree yuccas. Tormented, thin forests of it stalk drearily in the high mesas, particularly in that triangular slip that fans out eastward form the meeting of the Sierras and coastwise hills where the first swings across the southern end of the San Joaquin Valley. The yucca bristles with bayonet-pointed leaves, dull green, growing shaggy with age, tipped with panicles of fetid, greenish bloom.

CHOLLA SLAB OBLIQUE AND REGULAR (IN PARENTHESES)

Before the **** has come to flower, while yet its **** is a creamy cone-shaped *** of the size of a small **** full of **** the Indians twist it deftly out of its brace of **** and roast it for their own delectation. So it is that in those parts where man inhabits one sees young plants of **** infrequently.

aAₐAaAAaA

CHOLLA SLAB REGULAR
ABCDEFGHIJKLMNOPQRSTUVWXYZabcdefghij
klmnopqrstuvwxyzfifiβæœÀÁÂÃÄÅÀÇÈÉÊ
ÌÍÎÏÑÒÓÔÕÖÙÚÛÜŸàáâãäåçèéêëíìîïñòóôõöùúû
üÿ0123456789{[[*/.....:;?!!§$¢£¥€%‰++=]|¶§†‡
ÆŒ☞☜☟☛TMBO☝#_\~~⌐⌐═⌐═]}}

CHOLLA SLAB OBLIQUE
ABCDEFGHIJKLMNOPQRSTUVWXYZabcdefghij
klmnopqrstuvwxyzfifiβæœÀÁÂÃÄÅÀÇÈÉÊËÌÍÎÏ
ÑÒÓÔÕÖÙÚÛÜŸàáâãäåçèéêëíìîïñòóôõöùúûü
ÿ0123456789{[[*/.....:;?!!§$¢£¥€%‰++=]|¶§†‡
ÆŒ☞☜☟☛TMBO☝#_\~~⌐⌐═⌐═]}}

Other yuccas, cacti, low herbs, a thousand sorts, one finds journeying east from the coastwise hills. There is neither poverty of soil nor species to account for the sparseness of desert growth, but simply that each plant requires more room.

CHOLLA SLAB BOLD
ABCDEFGHIJKLMNOPQRSTUVWXYZabcdefgh
ijklmnopqrstuvwxyzfifiβæœÀÁÂÃÄÅÀÇÈÉÊ
ÌÍÎÏÑÒÓÔÕÖÙÚÛÜŸàáâãäåçèéêëíìîïñòóôõö
ùúûüÿ0123456789{[[*/.....:;?!!§$¢£¥€%‰++=]
|¶§†‡ÆŒ☞☜

CHOLLA SLAB BOLD
ABCDEFGHIJKLMNOPQRSTUVWXYZabcdefghij
klmnopqrstuvwxyzfifiβæœÀÁÂÃÄÅÀÇÈÉÊËÌÍÎÏÑ
ÒÓÔÕÖÙÚÛÜŸàáâãäåçèéêëíìîïñòóôõöùúûüÿ012345
6789{[[*/.....:;?!!§$¢£¥€%‰++=]|¶§†‡ÆŒ☞☜☟☛

So much earth must be preëmpted to extract so much moisture. The real struggle for existence, the real brain of the plant, is underground; above there is room for a rounded perfect growth. In Death Valley, reputed the very core of desolation, are nearly two hundred identified species.

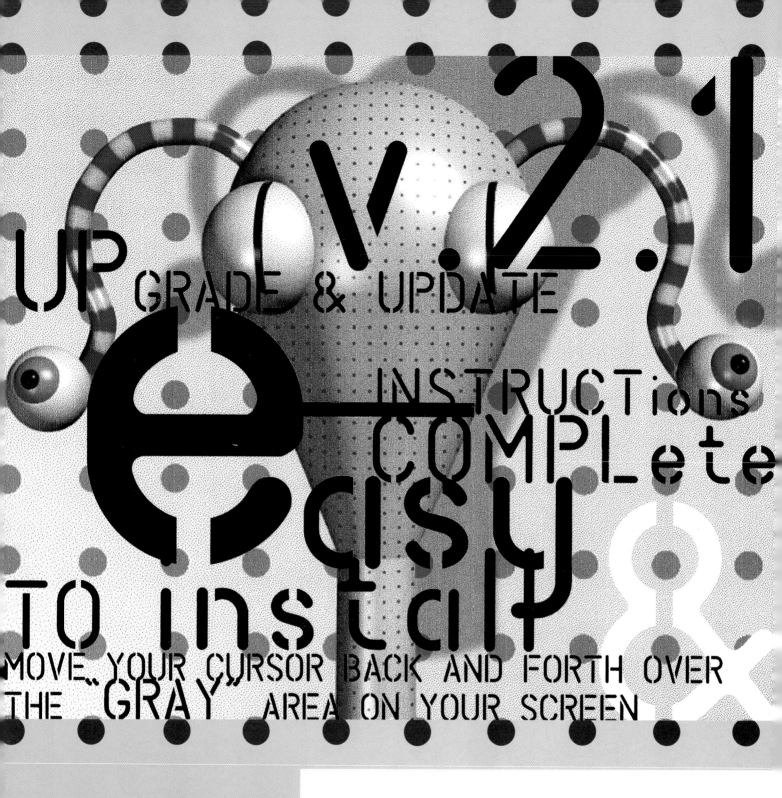

ev2.1

UP GRADE & UPDATE

e

INSTRUCTions
COMPLete
easy
TO install

MOVE YOUR CURSOR BACK AND FORTH OVER
THE GRAY AREA ON YOUR SCREEN

typeface design promotion (see also pp. 24–27)
This series of images is used online to promote a range of new
typefaces. For each typeface, the full font is displayed alongside
an image overlaid with a phrase reproduced in the typeface itself.
This novel take on the font catalog draws our attention through
its use of jarring or provocative text; the arrangement of type and
image shows how the font can be used for maximum impact.

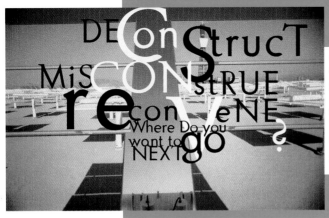

ABCDEFGHIJKLMNOP
QRSTUVWXYZabcdef
ghijklmnopqrstuvwxy
z1234567890!@#$%
&*()+{}[]?/:;.,""

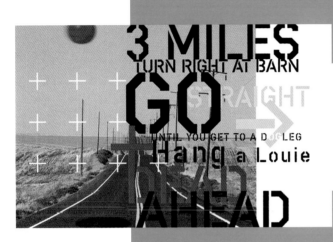

ABCDEFGHIJKLMNOPQRS
TUVWXYZabcdefghijklmn
opqrstuvwxyz123456789
0!@#$%&*+(){}[]?/:;.,""

ABCDEFGHIJKLMN
OPQRSTUVWXYZab
cdefghijklmnopq
rstuvwxyz12345
67890!&?:;.,""

ABCDEFGHIJKLMNOPQRS
TUVWXYZabcdefghijklmn
opqrstuvwxyz1234567890
!@#$%&*(){}[]?/:;.,""

great graphic designers somtimes have a curious disposition

Designer
Gerry Chapleski

Art director
Gerry Chapleski

Photographers
Stock

Design company
words+pictures

Country of origin
USA

Description of artwork
Typefaces and promotional images

Dimensions
Website

rstuvwxyz1 2
jklmnopqrstuvwxyz12
3 4 5 6 7 8 9 0 ! @ # $ % & * () +
{ } [] ? . / < > : ; , . " "

rstuvwXYZabcdefghi
jklmnopqrstuvwxyz12
34567890!@#$%&*()+
{}[]?./<>:;,." "

Quasi-
morphic
Zgrba
CULTUREISOCOMG
2.3.60

5 6 7 8 9 0 ! @ # $ % & * () +
5 6 7 8 9 0 ! @ # $ % & * () + { } [] ?

Ching
trip
MAYBE YOU SHOULD HIT THAT BACK BUTTON
4 @ }
Go West
Space
go

A B C
P Q R
e f g
v w x
@ # $
G

United States
Onstitution
*2570
FOUR SCORE
Self-Evident
[George DID It]

SHE WAS A
Pretty Girl
DEVOted Daughter
TRUSTED
CONfidante
BOSTON SOCIALITE
2:35 Dead

A B C D E F G H I J K L M N
Q R S T U V W X Y Z a
g h i j k l m n o p q r s t
y z 1 2 3 4 5 6 7 8 9 0 ! @ # $ %
& * () { } [] ? / : ; . , " "

That's
Life
Some days are GOOD
Some days are
BAD
Some
days
Suck
! @ # % & ? *

ABCDEFGHIJKLMNOP
QRSTUVWXYZabcdef
ghijklmnopqrstuvwx
yz1234567890!@#$%
& * () { } [] ? / : ; . , " "

Designer
Gerry Chapleski

Art director
Gerry Chapleski

Photographers
Stock

Design company
words+pictures

Country of origin
USA

Description of artwork
Typefaces and
promotional images

Dimensions
Website

An infant enters, sucks and twists, scratches, and ridges. Response: secretions release, flow, envelope, and harden in concentric palates around the particle. Collaboration and time, turning, working, and birth: a lustrous pearl.

ALL LECTUR
Lectures are Free

The EDA is loc
of the UCLA ca
in Westwood (

Parking may be

Expanded Design 15 (180

Tuesday, January

15

|D||o||n||a||l||d||‾||‾||‾||‾||N||O||R||M||A||N|
|/‾\|/‾\|/‾\|/‾\|/‾\|/‾\|‾|‾|‾|‾|/‾\|/‾\|/‾\|/‾\|/‾\|/‾\|

Co-Founder of the Nielsen Norman Group, Educator, & Writer.
The Design of Everyday Things.

Monday, January

28

|E||d||‾||‾||F||E||L||L||A|
|/‾\|/‾\|‾|‾|/‾\|/‾\|/‾\|/‾\|/‾\|

Designer, Experimentalist, & Educator.
Exit-Level Designer.

Thursday, February

14

|E||l||l||e||n||‾||‾||‾||L||U||P||T||O||N|
|/‾\|/‾\|/‾\|/‾\|/‾\|‾|‾|‾|/‾\|/‾\|/‾\|/‾\|/‾\|/‾\|

Curator, Writer, Educator, Graphic Designer,
& Partner, Design/Writing/Research.
Skin: Surface, Substance and Design.

Monday, February

25

|L||o||u||i||s||‾||‾||‾||C||A||S||T||L||E|
|/‾\|/‾\|/‾\|/‾\|/‾\|‾|‾|‾|/‾\|/‾\|/‾\|/‾\|/‾\|/‾\|

Co-Founder & General Manager of Westwood Studios, Game Designer.
Game Design Process,
Examples From Westwood Studios.

Monday, March

11

|D||a||v||i||d||‾||‾||‾||W||I||L||S||O||N|
|/‾\|/‾\|/‾\|/‾\|/‾\|‾|‾|‾|/‾\|/‾\|/‾\|/‾\|/‾\|/‾\|

Artist, Designer, & Curator.
The Museum of Jurassic Technology.

AT **6** P.M.
to the Public.

in the EDA *on the* CAMPUS *of* UCLA.

For information please call 310/825-9007.

Dickson Art Center on the northeast corner
the intersection of Sunset Blvd and Hilgard Ave
San Diego/405 Freeway). Sunset Blvd exit.

for $6 at the information kiosk located at Hilgard and Wyton.

HUHTAMO AND GAIL SWANLUND

UCLA lecture series: poster

Images based on the observation and analysis of the human body are used to promote this series of public lectures entitled "Expanded Design". The deconstructed type over the image pushes the boundaries of legibility and challenges conventional concepts of information design, so inviting the viewer to closely scrutinize the poster and generating interest in the event.

Designers
Gail Swanlund, Geoff Kaplan

Design company
Studio Swanlund and General
Working Group

Country of origin
USA

Description of artwork
Poster for university lecture series

Dimensions
17 x 22 in
432 x 559 mm

CUT OUT
LICHT PINK
LETTERSHAPES
LIKE USED
IN SHOPS
IN TSJECHIE.
FOUND (1995)
IN PRAGUE!★

TSJECHO

HANGING ON OUT

WIREANDPLANKS

Designer
Martijn Oostra

Design company
2 Rebels

Country of origin
The Netherlands /
Canada

**Description of
artwork**
Font sample booklet
and logo

Dimensions
Booklet
$5^3/_4$ x $11^1/_2$ in
148.5 x 297 mm

Font samples and logo (see also pp. 32–35)

Found objects are worked into formal fonts by this inventive design group, whose work is permeated by a strong sense of typography. Many of the pieces featured here were collected together for a booklet titled *Revolt* (unpublished), and demonstrate the proliferation of original typeface design in the digital age.

boom roos vis
vuur boog pim
pijl reus
0123 6789
12 + 5 = 17
8 ÷ 2 = 4

BOOM ROOS
VIS VUUR
BOOG PIM
PIJL REUS

Educational

tower above terror

Mould
Archi

ABCDEFGHIJK_MNOPQRSTUVWXYZ-123-567890-	
	qwertyuiopasdfghjklzxcvbnm ./?
	qwertyuiopasdfghjklzxcvbnm ./?
	qwertyuiopro,ject 1997 № 00.
M.O.	

PROVERBIALLY

commit

NO

crime!

blacKMAIL

harvey nichols: window display

These window displays at London's Harvey Nichols department store promote a new in-store retail outlet – "Beyond Beauty". The concept for the seven windows is loosely based around the senses: the keywords appear to be etched into the glass and invite the viewer to enter the ethereal sensory world within. The monumental size of the type, coupled with its translucency imply the strength and subtlety of the world within.

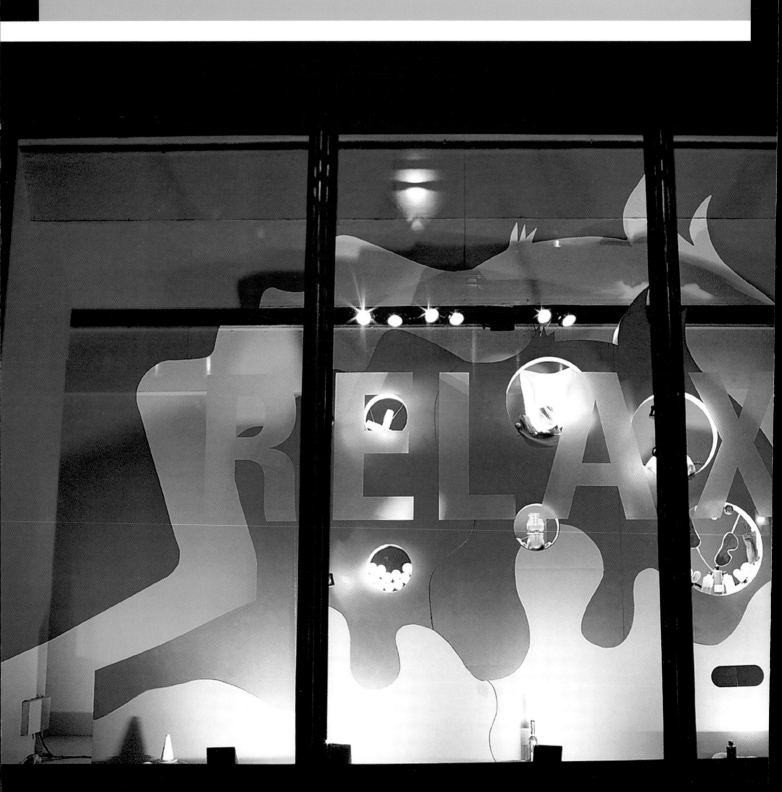

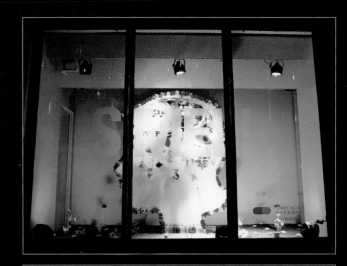

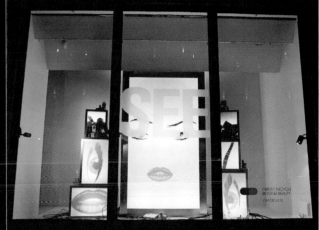

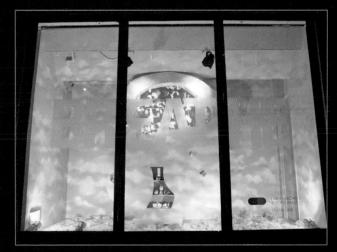

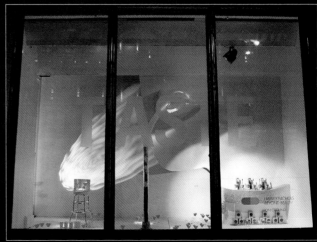

Designers
Caroline Moorhouse,
Peter Chadwick

Art directors
Caroline Moorhouse,
Peter Chadwick

Illustrator
Jo Berger

Design company
Zip Design

Country of origin
UK

**Description of
artwork**
Window display

Dimensions
$13^{1}/_{4}$ x $19^{3}/_{4}$ ft
4 x 6 m

freeze frame
download
execute
freeze frame
download
execute

.com

Volume One

Noise Fusion a journey into visual poetry containing the portfolio of various artists.

volume one
noise fusion
a series of movements and
perspective post modern times

Designer
Darren Irving

Design company
substance001

Country of origin
UK

Description of artwork
Brochures (left and far left) and teaser postcard (below)

Dimensions
Brochures
$11^1/_2$ x $8^1/_4$ in
297 x 210 mm
Postcard
$5^3/_4$ x 4 in
148 x 105 mm

contemporary design brochures and postcard

Type forms an integral part of the illustration on all three of these pieces, aimed at graphic artists. On the two brochure covers, the type is rendered in three dimensions in a sci-fi style and is given dynamism through an appearance of movement. The postcard, in contrast, gains strength through the apparent movement of the background: the static white type, lying on a band of muted color, is thrown to the forefront.

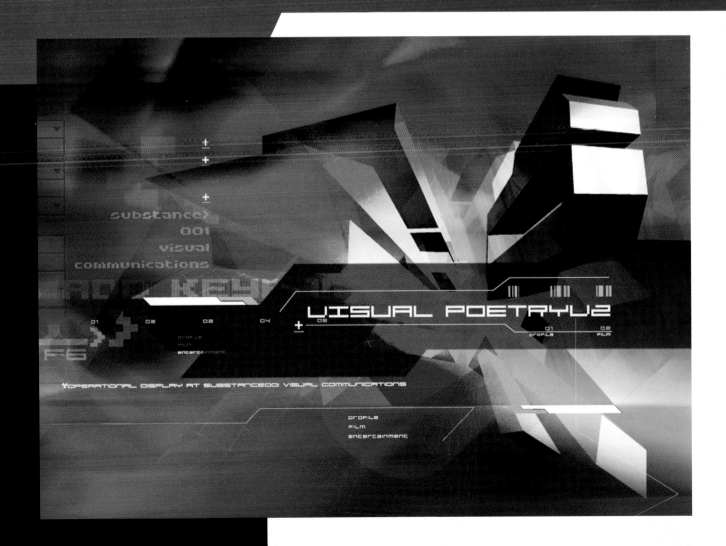

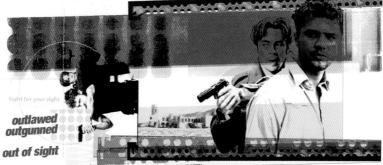

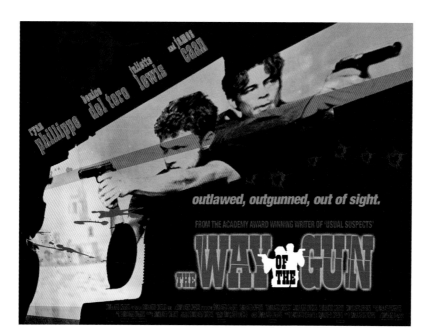

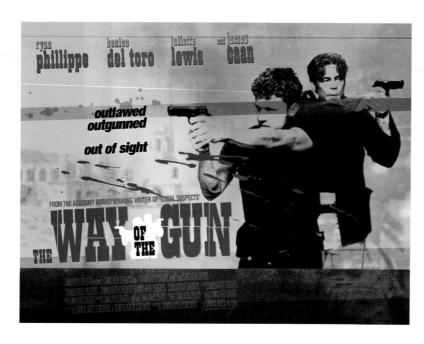

Designer
Darren Irving

Design company
Feref

Country of origin
UK

Description of artwork
Movie poster

Dimensions
40 x 30 in
1016 x 762 mm

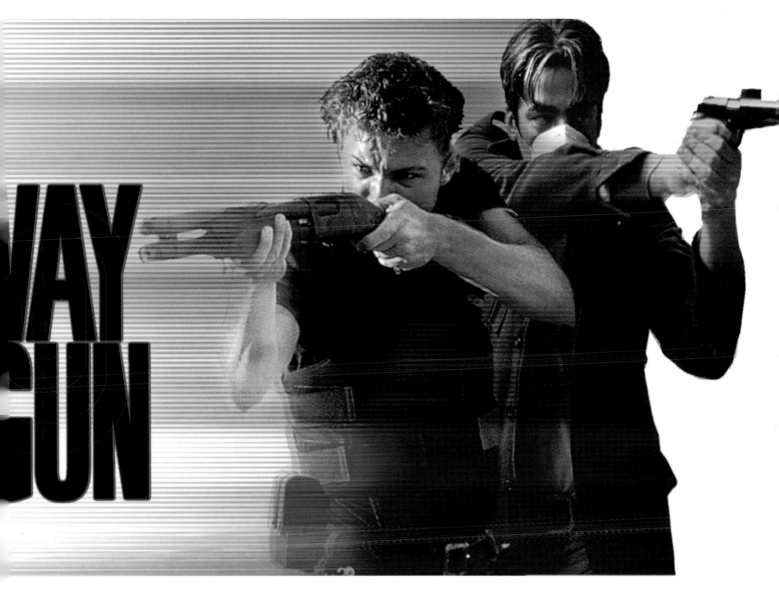

IPPE BENICO **DEL TORO** JULIETTE **LEWIS** AND JAMES **CAAN**

VAY
GUN

ATED CREDITS FILM · A SIMULATED CREDITS PRODUCTION SIMULATED CREDITS · SIMULATED CREDITS "SIMULATED CREDITS" SIMULATED CREDITS · SIMULATED CREDITS · SIMULATED CREDITS EDITED BY SIMULATED CREDITS BY SIMULATED CREDITS DIRECTOR OF SIMULATED CREDITS PRODUCTION DESIGNER SIMULATED CREDITS EXECUTIVE PRODUCER SIMULATED CREDITS PRODUCED BY SIMULATED CREDITS & SIMULATED CREDITS DIRECTED BY SIMULATED CREDITS A SIMULATED PICTURE

© 1998 SIMULATED PICTURE GROUP INC.

the way of the gun: movie posters
Four posters for a movie billed as a "modern day Western"
show alternative solutions to one brief. The three smaller
images to the left employ standard Western iconography:
a slab serif typeface, bulletholes, splashes of blood, and
faded photographs. In contrast, the fourth poster places
the movie squarely in a contemporary setting.

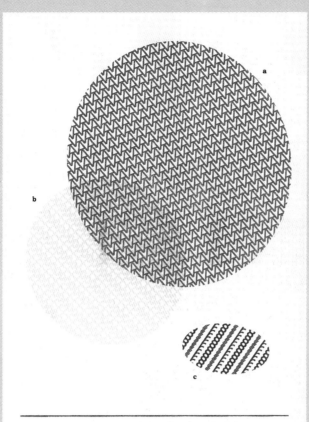

Dot dot dot N°4 (ISSN 1615-1968)
a. Archæological æsthetics **b.** Based on true stories **c.** Stroppy/Revelatory

dot dot dot no 4: magazine (see also pp. 44–45)

This magazine, which is concerned with the art of typography, avoids the easy temptation to adopt an overpowering design style of its own. Instead, the conventional simplicity of its layout allows space for the work that it analyzes. This specialist journal is uncompromising in the density of the information it contains. Though a relatively new arrival in this area of publishing, it has already developed an influential voice.

Designers
Stuart Bailey,
Peter Bilak

Design company
dot dot dot

Country of origin
The Netherlands

Description of artwork
Magazine

Dimensions
6¹/₂ x 8¹/₂ in
165 x 220 mm

extends to goods of all kinds: 'fashion designers' have become just 'designers'.

Such designers – the ones who design 'designer' goods – have apparently achieved a measure of control over the wider public. It seems, according to one TV commercial I have seen, that they can even make people ashamed to be seen with the wrong mobile phone – a kind of shame that can only have meaning within a designer-led tribal context. The old, Marxist-centralist kind of designer didn't care whether people felt shame or anything else. He or she simply knew what was 'best' in some absolute sense, and strove to make industry apply this wisdom. But 'designer' designers work the other way around. Far from wanting to control their commercial masters, they enthusiastically share their belief that the public, because of its irrepressible tribal vanities, is there to be milked. They have capitulated in a way that my *Typos* article fervently hoped they would not, but for the reason which it pointed out: in visual matters there is no 'one best way'. Exploiting this uncertainty is what today's design business is all about. The old, idealistic modernism that I once espoused is on the scrap heap.

And yet modernism lives on in the very structure of industry and the way designers of all persuasions earn their living. The very idea of design as a separate profession is part of an industrial movement that can be traced back as far as Adam Smith's idea of division of labour, which he put forward in 1776 and which reached full fruition with Frederick Taylor's *Scientific Management* in 1911. Taylor thought that everyone would be better off if people who made things just got on with making them and didn't stop to think. The thinking would be done for them by specialists who detailed every little action. He called these specialists 'managers', but in many cases they were really designers. The idea was to reduce well-rounded artisans to obedient robots who worked at maximum possible speed while the intellectual skills that were formerly part of the job were handed over to white-collar workers. Taylor's influence on the way work is organised has been so profound that today we hardly notice it – how else would you do things? Designer-artisans do still exist – fine printers, furniture makers – but somehow they are outside the mainstream. Because they are not modern, not industrialised, we feel, they don't really count.

So my naïve idea of the 1960s – that designers were part of the solution to the world's chaotic uncontrollability – was precisely the wrong way round. Today's designers have emerged from the back room of purist, centralist control to the brightly lit stage of public totem-shaping. Seen from the self-same Marxist viewpoint that I espoused in those ancient days, they are now visible as part of the problem, not the solution. They have overtly accepted their role as part of Taylorist capitalism. Designers are now exposed, not as saviours of the planet but as an essential part of the global machinery of production and consumption. Does anyone care? End of statement.

" :text ends

Black/Red/Blue

PAGE 45

DISREPRESENTATIONISM NOW!

EXPERIMENTAL JETSET

PAGE 44

DISREPRESENTATIONISM NOW!

EXPERIMENTAL JETSET

Disrepresentationism. Disrepresentation Now!

01.

One.

On the social, political, and revolutionary role of graphic design.

More an attempt than a manifesto.

File under:
/ Experimental Jetset
/ Washington DC
/ Voice 2001 AIGA

Two.

In his vicious 1923 manifesto "Anti-Tendenzkunst", De Stijl founder Theo van Doesburg stated that "as obvious as it may sound, there is no structural difference between a painting that depicts leading a red army, and a painting that depicts Napoleon heading an imperial army. It is irrelevant whether a piece of art promotes either proletarian or patriotic values".

This quote can be easily misunderstood as blatantly political, but in our humble opinion, it is far from that. In Van Doesburg's view, it is the act of depiction itself, the process of representation, that he regarded as highly anti-revolutionary.

Van Doesburg and many other modernists saw representation as inherently bourgeois; suggestive, tendentious and false. Regardless of the subject.

Three.

Although formulated almost a century ago, we, as Experimental Jetset, have to admit we feel a certain affinity for Van Doesburg's "anti-tendentious" ideas.

Although at first sight it might seem impossible to differentiate between "representative" graphic design and "presentative" graphic design, we think it is possible to make a distinction of some sort.

For example, it's hard to deny that most graphic design produced within the context of advertising is inherently representative, as per definition, advertising dissolves its own physical appearance, in order to describe and represent appearances other than itself; never "is" in itself, it always "is about" something else.

Advertising is a phenomenon that constantly dissolves its own physical appearance, even when it is referring to subjects other than itself.

(Whereas presentative graphic design seems to underline its own physical appearance, even when it is referring to subjects other than itself).

/ Please keep in mind that "physical entity" does not necessarily mean printed matter. Websites, music, movies, fragrances etc. as very concrete, physical entities.

/ An argument sometimes used by representative graphic designers to defend its denial and neglect of the physical dimensions of graphic design is the environmental issue. We don't think of this as a valid point.

designers to confuse the derivatives of design (images, information, content, communication) with the design itself.
By this they deny and neglect the fact that a piece of design is above all an object, a physical entity;
/ That is exactly why we don't think of graphic design in terms of "visual communication", "information architecture" or "experience design".
All these notions confuse the many effects and functions of design with the design itself.

04.

Four.

Having said all this, we would like to point out that our criticism of advertising is fundamentally different than the criticism expressed in the 2000 First Things First manifesto.

Other than the signatories to that manifesto, we see no structural difference between graphic design and advertising. Every cause that is formulated outside of a piece of design, and thus superficially imposed on a piece of design, whether it deals with corporate interest or social causes.

Likewise, we see no structural difference between advertising and "anti-advertising". The former tries to sell you product X, the latter tells you not to buy product X, but on a fundamental level they are completely alike. They both contribute to what Guy Debord was so fond of referring to as 'the society of the spectacle': a world of representation, alienation and nothingness.

Five.

Other representative tendencies in graphic design include the fact that nowadays more and more designers refer to their profession in terms such as

/ The bigger the focus on the material side, the bigger the respect for the natural resources.

Six.

In "The Republic", Plato has Socrates tell the allegory of the cave, watching shadows... We're still imprisoned in this same reality, through preventative culture. The immorality of advertising and the morality of anti-advertising are two sides of the same coin. What we need is form of graphic design that is neither immoral nor moral, but amoral. That is productive, reproductive. That is constructive, not parasitic.

We believe that abstraction, a movement away from representation but towards reality, is the ultimate form of engagement. We believe that to focus on the physical dimensions of design, to create a piece of design as a functional entity, as an object in itself, is the most social and political act a designer can perform.

That's why we believe in color and form, type and spacing, paper and ink, space and time, object and function; and, most of all, context and concept.

/ Experimental Jetset
/ Amsterdam 25.06.2001

"Formal Conventions / Conventional Formas" and "Disrepresentation" were written and designed specifically for the Washington DC 2001 AIGA Voice Convention.

Text and design by Experimental Jetset 2001.
Printed by Drukkerij Rob Stolk bv, Amsterdam.
Supported by the Foundation for Fine Arts, Design and Architecture, the Netherlands.

www.aiga.com
www.experimentaljetset.nl

text begins: "

The 'Swiss style' of graphic design came fresh from Basel and Zurich nearly half a century ago. And it is still with us in the form of Helvetica, Univers, and grid systems. The style was internationally promoted for several years through a quarterly journal, *Neue Grafik* (New Graphic Design), where it was presented as an ideological movement linked to the Modernist tradition and its founding fathers, Jan Tschichold and Max Bill. Their obvious successor was Karl Gerstner.

Gerstner denies that he was himself a pioneer. **After the trailblazers of the teens and twenties, he wrote, we are the settlers, the colonisers.** In 1955, he edited, designed and was the chief contributor to a special graphic design issue of the monthly *Werk*, where he surveyed the territory which the pioneers had staked out; he recorded its development and made suggestions for its future. This was the first clear summary of what was meant by 'graphic design'.

Gerstner was then only 25 years old but the articles in *Werk* plotted paths which his career was to follow and the landmarks he

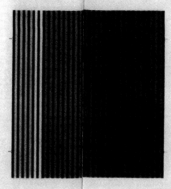
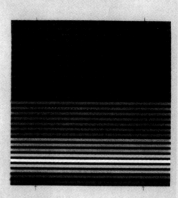

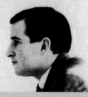

Auto-portrait with three paintings, 1957.

the text in bold Monotype Grotesque, alternating between two column widths. Gerstner developed this flexible, unconventional technique in an often-reproduced book design, for Kutter's experimental novel, *Schiff nach Europa* (Boat to Europe), published in 1957.

In the new layout of *Werk*, Gerstner had followed the lead of Richard Paul Lohse's *Bauen+Wohnen* monthly, which had used Monotype Grotesque since 1949. But Gerstner's setting was unjustified, ranged left, a method he had used at Geigy in a calendar for farmers. This was an innovation for magazine text. The two columns were placed asymmetrically, to the right of each page. Paragraphs were indicated by a line space, without a first-line indent. Illustrations were limited to 16 possible proportions and sizes by a horizontal and vertical grid.

For Gerstner, the grid was to become essential to his 'programmes'. With *Schiff nach Europa*, the grid provided the integration of typography and surface area : the type area is derived from this space, in other words, from the outside to the inside. So, the area is first divided into squares, 2×3; the squares into units, 7×7; the units into 3×3 units of body size, the smallest typographical measurement – type size and leading. This results in a flexible grid, in which the type area can fit with an (almost) unlimited freedom.

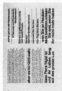
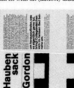
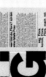

Two spreads from *Schiff nach Europa*, 1957.

The range and variety of column widths and sizes of type, still within the limits of metal typesetting, are used to echo Kutter's diverse styles of writing and the characters' way of speaking. *Schiff nach Europa* is 'a synthetic novel, a hypothetical play', describing a boat journey from New York to Le Havre. The book explores narrative (and typographic) styles: beginning as a conventional novel, it becomes a play; a traveller's night-time musings are set out in unbroken prose. One chapter exaggerates the role of quantity, the numbers stressed in bold type. Another is journalistic, set in newspaper style at 90 degrees. There are also paragraphs showing the alphabet as signs, set in lower-case.

This was advanced design for a sophisticated, literary audience. But Gerstner was also working again for Geigy, whose 200th

Diagram and double page from *Geigy today*, 1958.

anniversary was celebrated in 1958 in the book *Geigy heute* (Geigy today), designed by Gerstner and edited by Kutter. *Geigy heute* is the most comprehensively typical example of Swiss graphic design. All the elements are present, handled with inventiveness: a square format with a square-backed binding; Akzidenz Grotesk for headings, Monotype Grotesque for text, all of which was unjustified; statistical charts, black-and-white halftones, topographical photographs overlaid with red rules identifying Geigy buildings (black, red and grey were Gerstner's preferred typographic inks). There are ingenious diagrams of management structures, and departmental organisation is demonstrated by photographs of technicians at work overlaid on blocks of flat colour, linked and related by fine arrows. The scope of the firm's activities is shown by photographs of staff at work, mainly in colour. The book, more than 300 pages, ends with a sober listing of Geigy products.

In 1964 Gerstner brought together his thinking on all his fields of activity in the book *Programme entwerfen* (Designing programmes), which was translated in an enlarged edition four years later. This was

Karl Gerstner:
Designing Programmes

Programme as typeface
Programme as typography
Programme as picture
Programme as method

Designing Programmes, cover to the English second edition, 1968.

Voice. Conventional Formats. AIGA2001 Format Conventions.

text begins: "

A number of books and reviews have recently attempted to identify philosophical tendencies in the work of the Czech writer Milan Kundera. He has been described as a writer who uses sharp irony to critique the decay of modern society. I am not entirely convinced by this description. Milan Kundera has always been a novel man. Throughout his books, he has attempted to use the format of a novel to create a way of thinking that is specifically novel-like (not abstract, not theoretical, not philosophical, but questioning and provocative). Meditation or reflection are an integral part of his novels, converging with narrative threads to form a coherent whole.

 The following notes explore a few interlocking themes, which seem to overlap with everyday design issues: uniqueness, identity, composition, translation, logic and originality. The diagram attempts to delimit Kundera's ideas of what constitutes a novel in a manner as unrefined as these thoughts.

In an era where everything is being adapted – books to films, games to cartoons, cartoons to books, books to theatre plays, theatre plays back to films – Kundera is striving to achieve an absolute originality in his writing which is impossible to imitate in another form of art. He rejects adaptations, instead devoting his life to making a novel that it is not possible to reduce or rewrite. 'If the meaning of a novel survives its rewriting, it is an indirect proof of a low value of the novel', commented Kundera in the foreword of *Jacques and his Master* (1981).

A good novel cannot be anything other than a novel. After an adaptation only an insignificant storyline remains. 'All the transpositions of *Anna Karenina*, that we know from theatre or movies are adaptations, thus reductions. The more the adaptor strives to discreetly follow a novel's path, the more he betrays it. The reduction removes the elegance and meaning of the novel.' The uniqueness of his expression culminates in his novel *Immortality* (1990) where the text is intentionally fragmented to the extent that the novel cannot be reduced to a reproducible story. In this way, the book redefines and broadens the conventional definition of the novel.

In *Immortality*, Kundera succeeded in establishing a kind of novelistic poetry that he has been consciously following since *The Joke* (1967). He removes the heavy burden of realism and constantly reminds the reader that the text he is reading is just an illusion. The reader is invited to take part in the game. Kundera's writing is synthetic: he makes reflection a natural part of the novel, yet avoids abstraction or theory.

Almost everything I have experienced in my life: books, art, music, film, magazines, cars, furniture, clothes, fast or frozen food, even people sometimes, have been in reproduction. Copies. Mass produced or reproduced... But of course, this IS the authentic for my generation. The idea of an aura of authenticity surrounding an object is strange and foreign to us.[g]

I am lost... like most people in the West my loss of faith is sad and dangerous... We take the strangest things as substitute for our lost faith: art, psychiatry, work, scientific logic, fashion, the digital future, communism, money, and self improvement courses... All of them might work a little while and then we have to move on to the next one. We sense that the things, objects and places around us are alive, not just the dead matter that science would have had us to believe. We sense the world around us as a living organic system... with something like a soul... And the arts, including photography, are something we have that has remained somewhat uncontaminated... they are means of touching the parts that the official stuff can't reach.[h]

The impulse to attribute human attributes to objects is not stupid or wrong, as many scientists keep telling us time and again... we cannot be separated from the objects that surround us. They animate and imitate us just as much as we imitate objects and animate them. By breathing a soul into dead objects, we feel and understand that the world is truly alive, not just existing as an aggregate of dead objects and lifeless landscapes.[i]

God created Sins! ... Sins are woven into the fabric of our lives. ... To abandon and ignore sin is to ignore and reject God's handiwork.[j]

THE NEW SINS

New testament

Byrne's most recent book, *The New Sins*, is best read with an open mind for the simultaneity of ironic and serious intentions.

 Commissioned in 2001 by the Valencia Biennial, it is a bilingual English/Spanish book of text and photos, designed by Dave Eggers to resemble religious literature, especially the catechisms that are often presented at graduations and religious ceremonies. Pocket-sized, bound in wine-red imitation leather and lettered in gold, it is the kind of book one might find on a hotel room bedside table, or get offered in the street by Jehovah's Witnesses, Hare Krishnas, or followers of Scientology, trying to make converts. As such, it follows logically from Byrne's long-standing interest in unorthodox religious literature, those fascinating books (photographed in *Strange Ritual*) that according to Byrne 'promise the world and in most cases deliver disappointment.'

 The visual and literary qualities of such literature have been imitated carefully. The front cover carries the legend 'translated out of the original tongues with the former translations diligently compared and revised.' The Old Testament is mimicked, in sentences such as 'The Heart is like the Sea, wherein dwells the Leviathan, and creeping things innumerable.'[g] And apart from the graphic features, the juxtaposition of photos and text undermines any projection of symbolic meanings. The text is rife with 'key words' printed in red, in capitals or underlined; many words and phrases begin with capitals; and ample use is made of rhetorical questions, non-sequitur arguments, bewildering admonitions and wild metaphors. The general drift of the text, however, is an appeal to the reader (especially the art-conscious, culturally aware, contemporary reader) to find and consider the structures of belief in unsuspected locations, outside the traditional framework of religion.

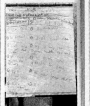

Sins are made by Him – to enjoy and use until they have been eventually understood. Each culture and the society make their sins – sins are not eternal, fixed and forever. They are constantly and eternally in flux.[j]

Hope allows us to deceive ourselves into thinking that life is parcelled into discrete chunks – that our lives are stories with beginnings, middles and ends. That there IS narrative, linearity, and not chaos, chance and luck.[k]

Byrne enumerates ten new sins: charity, sense of humour, beauty, thrift, ambition, hope, intelligence/knowledge, contentment, sweetness, honesty, and cleanliness. Each is characterised by a brief explanation and a photograph, mixing humour, religious metaphor, exaggeration and irony. A fold-out page at the centre of the book adds more categories of sin in a hierarchical structure (after Dante's *inferno*): sins of extreme self-control, sins of self-denial, sins of extreme logic, and sins of ideological adherence.

All in all, it seems safe to conclude that Byrne's new sins spring from neglect: neglect of the accidental, the juxtaposed, the unintended, the allegorical, the heterogeneous, the reflexive. Aren't those also the sins that are most often committed by design?

" :quotes end

" :text ends

Quotes references

a. See Byrne's Introduction in Lewis Blackwell, *The End of Print: The Graphic Design of David Carson*, (London, Lawrence King Publishing, 1995)
b. Byrne, 'The Holy Grail of No Style', in Hall and Bierut (ed.), *Tibor Kalman: Perverse Optimist* (New York, Princeton Architectural Press, 1998), p.87.
c. Byrne, interviewed by Herman van der Horst and Bart van de Kamp, *Muziekkrant Oor* nr.1, 1986), p.12.
d. Byrne, text in the booklet of his CD *The Forest*, February, 1991.
e. Byrne, insert in *Parkett* nr.23, 1990, p.120/126.
f. Hall and Bierut (ed.), *Tibor Kalman: Perverse Optimist* (New York, Princeton Architectural Press, 1998), p.87.

g. Byrne, 'End Notes', in *Strange Ritual: Pictures and Words*, (London, Faber and Faber, 1995).
h. Byrne, interviewed by Elisabetta d'Erme in Alias, weekly insert with *Il Manifesto*, 1998.
18. Byrne, interviewed by Marco Pantini, *Il Progetto* nr. 4, 1998.
i. Byrne, leaflet published by Aktionsforum Praterinsel, Munich, Germany, to accompany his show *Glory! Success! Ecstasy!*
j. Byrne, *The New Sins*, (New York, McSweeney's Books and London, Faber and Faber, 2001, pp.13-15.
k. Byrne, *The New Sins*, (New York, McSweeney's Books and London, Faber and Faber, 2001) p.39.

Text references

1. See Theodore Shank, *American Alternative Theatre* (Macmillan, London, 1982), pp.125–7.
2. Byrne collaborated with Wilson on two of the latter's major productions: the *CIVIL warS* in 1984, and *The Forest* in 1988.
3. See Richard Schechner, *The End of Humanism: Writings on Performance* (New York, Performing Arts Journal Publications, 1982), pp.20–21; and his *Between Theater & Anthropology* (Philadelphia, University of Pennsylvania Press, 1987), p.221.
4. Richard Schechner, *The Future of Ritual: Writings on culture and performance* (London: Routledge, 1993), p.241.
5. Rauschenberg had already made similar work in the sixties, *Revolvers*, consisting of a series

of large transparent disks full of photographically reproduced images, mounted in special holders. These pieces were made for art collections, whereas the album cover was intended for mass production; some 25,000 copies were printed.
6. C.G. Jung, *Psychology and Alchemy* (second edition). *Collected Works, vol. 12*, (London, Routledge & Kegan Paul, 1968), p.41.
7. C.G. Jung, *Psychology and Alchemy* (second edition). *Collected Works, vol. 12*, (London, Routledge & Kegan Paul, 1968) p.18n.
8. Tibor Kalman, quoted in Liz Farelly, *Tibor Kalman: Design and Undesign* (London, Thames and Hudson, 1998).
9. *The New Sins* (New York, McSweeney's Books, and London, Faber and Faber, 2001), p.47.

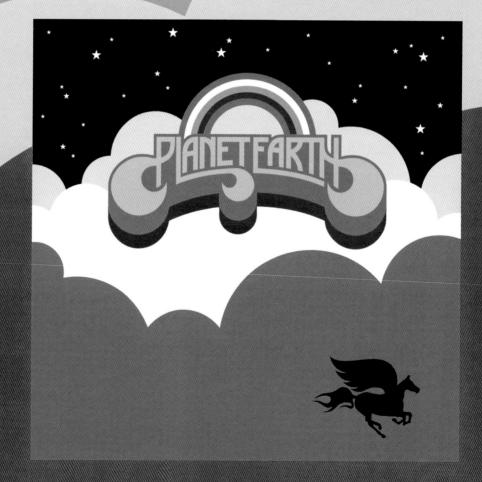

Designer
Rinzen

Design company
Rinzen

Country of origin
Australia

Description of artwork
Club posters and flyer

Dimensions
Various

club posters and flyers (see also pp. 48–49)

Heavily influenced by the explosion of music and political propaganda in the 1960s, these promotional items rely on the vibrant, direct impact of bold, flat color, printed over large areas. The design of the typefaces also recalls the '60s – a period when the reproduction of type moved from letterpress to photomechanical transfer. This technological advance allowed typographers unprecedented freedom in the design of fonts and characters.

A ROOM40 EVENT

DJ OLIVE MEETS I/O
GREGOR ASCH LAWRENCE ENGLISH TAM PATTON HEINZ RIEGLER
BRISBANE POWERHOUSE SPARK BAR
SUNDAY NOVEMBER 11
4:00 PM FREE

THE POWERHOUSE IMPROVISED
SESSION TURNTABLES LAPTOP
KEYBOARDS GUITARS GREGOR
LAWRENCE TAM HEINZ

RINZEN

Designer
Rinzen

Design company
Rinzen

Country of origin
Australia

Description of artwork
Club posters and flyer

Dimensions
Various

calendar

Twelve radical treatments of type – one for each month of the year – give this self-promotional calendar a contemporary, and highly distinctive personality. The "candy bar" style of graphics, with its simplified, flat-color illustrations, reinforces the youthful energy of the design studio.

august

"What was it like on the moon grandad?"
JACOB AGE 5

MON	TUE	WED	THU	FRI	SAT	SUN
				1	2	3
6	7	8	9	10	11	12
13	14	15	16	17	18	19
20	21	22	23	24	25	26
27	28	29	30	31		

july

"Why dont you ever see baby pigeons?"
PAUL AGE 25

MON	TUE	WED	THU	FRI	SAT	SUN
					1	2
3	4	5	6	7	8	9
10	11	12	13	14	15	16
17	18	19	20	21	22	23
24	25	26	27	28	29	30

september

"Why don't we see caterpillars anymore?"
JENNY AGE 27

MON	TUE	WED	THU	FRI	SAT	SUN
					1	2
3	4	5	6	7	8	9
10	11	12	13	14	15	16
17	18	19	20	21	22	23
24	25	26	27	28		

octobor

^
Ⓜ
v

MON	TUE	WED	THU	FRI	SAT	SUN
	1	2	3	4	5	
6	7	8	9	10	11	12
13	14	15	16	17	18	19
20	21	22	23	24	25	26
27	28	29	30	31		

"Why has nanny got a beard?"
SHELLY AGE 6

DECEMBER

^
Ⓜ
v

MON	TUE	WED	THU	FRI	SAT	SUN
					1	2
3	4	5	6	7	8	9
10	11	12	13	14	15	16
17	18	19	20	21	22	23
24	25	26	27	28		
29	30					

"Why does daddy think he's Santa?"
ANNA AGE 6

november

^
Ⓜ
v

MON	TUE	WED	THU	FRI	SAT	SUN
				1	2	3
5	6	7	8	9	10	11
12	13	14	15	16	17	18
19	20	21	22	23	24	25
26	27	28	29	30		

"Mum, can I have a party?"
LISA AGE 11

Designer
Darren Irving

Design company
substance001

Country of origin
UK

Description of artwork
Calendar

Dimensions
11¹/₂ x 8¹/₄ in
297 x 210 mm

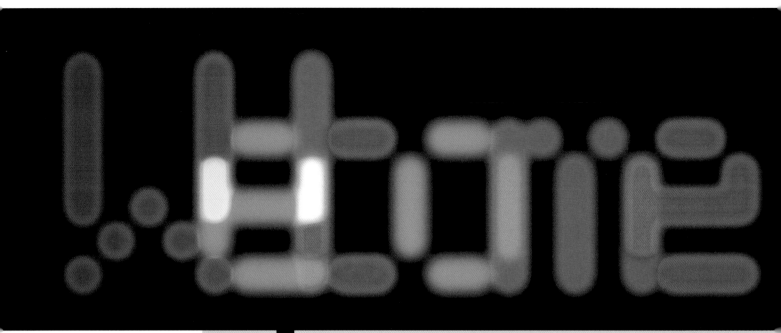

Designer
Julian Morey

Art director
Julian Morey

Design company
Julian Morey
Studio

Country of origin
UK

Description of artwork
Typographic design for Wired magazine (above) and various promotional cards

Dimensions
Various

magazine layout and promotional cards (see also pp. 54–55)
Well-executed and effective typography needs only minimal raw materials, as the following eight pieces demonstrate. This range of work exemplifies the use of characters themselves – and in some cases their constituent parts – as the building blocks of a design.

SANS SOLEIL

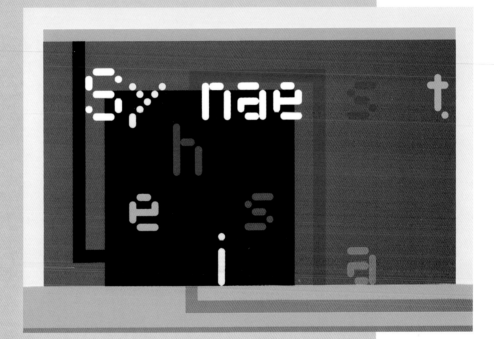

By name the sh e is t.

We Love repitition

THINK
AiME
20

Designer
Julian Morey

Art director
Julian Morey

Design company
Julian Morey
Studio

Country of origin
UK

Description of artwork
Promotional cards
and logos

Dimensions
Various

queensway bay tenant criteria handbook
This quirky booklet promotes the distinctive character of a new retail development to potential tenants. The bold use of color and archive photography, converted to monochrome graphics, differentiates the seven distinct retail areas. Colored type reinforces the identity of each area by highlighting key words and phrases in the promotional copy.

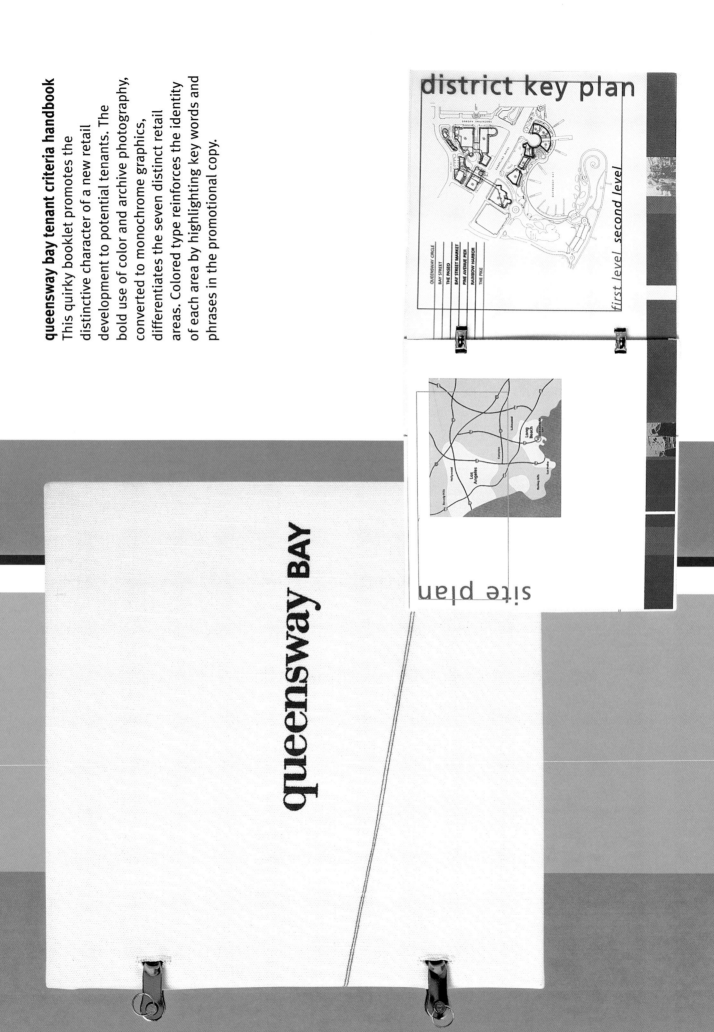

district key plan

first level second level

QUEENSWAY CIRCLE
BAY STREET
THE PASEO
BAY STREET MARKET
PINE AVENUE PIER
RAINBOW HARBOR
THE PIKE

site plan

queensway BAY

Designer
Grusje Bendeler

Art director
Don Hollis

Design company
Hollis

Country of origin
USA

Description of artwork
Handbook

Dimensions
$10^{3}/_{4}$ x $10^{3}/_{4}$ in
275 x 275 mm

pine avenue pier

bay street market

dahlia digital: promotional cards

The self-promotional cards produced by this New York-based design agency feature samples of work on one side, and a series of cryptic images of telephones from around the USA on the reverse. The highly diverse content of the cards is drawn into a unified style by the constants of color palette, position of type, and typeface.

interactive ↓ ← → ↑

DAHLIA DIGITAL
110 Greene St., no. 804
New York, NY 10012
p. 212.334.6557
f. 509.693.9801
www.dahliadigital.com

dahlia digital ↓ ← → ↑

DAHLIA DIGITAL
110 Greene St., no. 804
New York, NY 10012
p. 212.334.6557
f. 509.693.9801
www.dahliadigital.com

Designer
Cynthia Fetty

Art director
Cynthia Fetty

Illustrator
Amy Saidens

Photographer
Cynthia Fetty

Design company
Dahlia Digital

Country of origin
USA

Description of artwork
Dahlia Digital promotional cards

Dimensions
4 x 6 inches
102 x 152 mm

imagemd.com

ImageMD - From the beginning Dahlia Digital approached this project by looking at it more as a work of art than as a typical medical website. The site accentuates the beauty of the human form, and uses vibrant colors to entice the user. In order for ImageMD to convey a message of "enhanced appearance" the site had to be aesthetically pleasing to the eye. We also developed an easy to use navigation system which effectively organized the site's content.

Def Mix Productions - this is Dahlia's most recent music client. Look for the completed site in the Fall 2001!

TOUR DATES

About Us

We firmly believe that quality work is more important than quantity of projects, which makes us discerning when speaking with prospective clients. We prefer to build strong, long-term relationships with our clients, and foster productivity and understanding through each stage of a project's development cycle. The only way for each project to be a success is if our goal mirrors yours. Like a blooming dahlia, success unfolds only when the right elements have interacted and been nurtured in conjunction with care and attentiveness.

partial client list

Album Design
THIRSTY EAR RECORDS
KNR RECORDS
GEORGICA
DEF MIX PRODUCTIONS

Collateral Design
MR. PINK INC.
YOUR FICKLE
CHANNEL IT - CITI PRODUCTIONS

Web Design
FISKULT MEDIA VENTURES
SENSE.COM
CABOT McMULLEN INC.
PINK PUSHERS
DEF MIX PRODUCTIONS
HIPPO MOTION LLC
FREEZE OUT PRODUCTIONS LLC

Advertising Design
ATLANTIC RECORDS
SENSE.COM

Presentation Design
LEAGUE OF AMERICAN THEATRES AND PRODUCERS
ALBERT INC.

Services

Album Covers
Animation
Business Cards
Collateral development
Copy-writing
Illustration
Logo development
Magazine development
Media Kits
Media Planning
Motion graphics
Music Related Design
Online ad banners & promotions
Online advertising

Outdoor & Indoor signage
Outdoor advertising
Packaging
Photography
Print advertising
Promotion
Radio spots
Stationary packages
Trade Print ads

what can we do for you?
info@dahliadigital.com

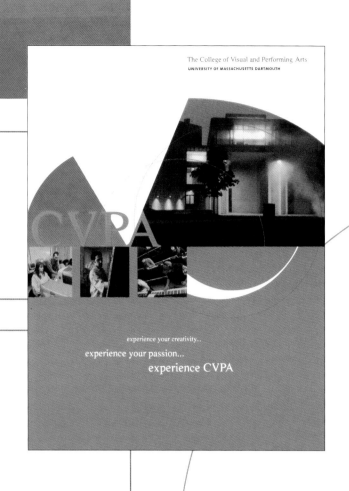

dartmouth college: prospectus

This brochure serves as an introduction to The College of Visual and Performing Arts at the University of Massachusetts, promoting their programs, faculty, and campus. The college's strong visual identity permeates the entire publication, which features just three colors throughout. Asymmetric typography and the use of abstract shapes has allowed the designer to produce dynamic layouts that reflect the diverse creative program offered by the college. Note the use of different styles and sizes of quotation marks to denote different "voices".

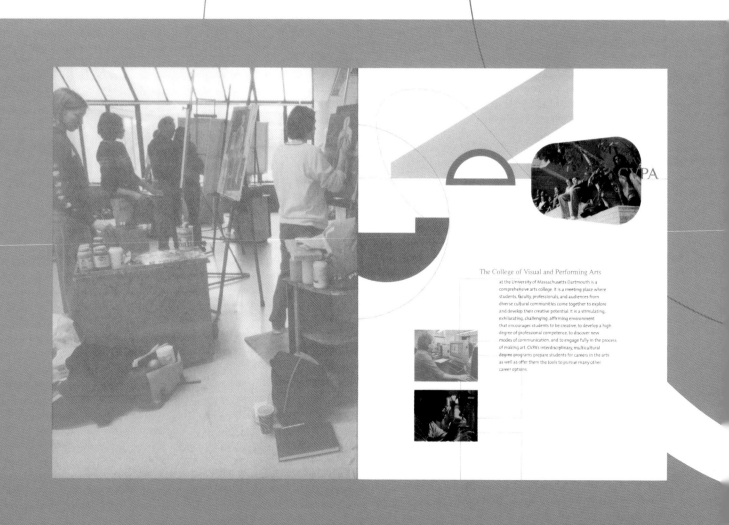

Designer
Tammy Dotson

Art director
Clifford Stoltz

Design company
Stoltze Design

Country of origin
USA

Description of artwork
College brochure

Dimensions
8¹/₂ x 11 in
217 x 280 mm

per SPEC tives

SPRING 2000

to view the contribution of your work in a larger framework

Bringing Value to Life

Building on our strengths

BlueCross BlueShield
of Florida

An Independent Licensee of the
Blue Cross and Blue Shield Association

per SPEC

Designer
Gerry Chapleski

Art director
Gerry Chapleski

Design company
words+pictures

Country of origin
USA

Description of artwork
Corporate in-house
magazine

Dimensions
8¹/₂ x 11 in
216 x 279 mm

Tracking the Pulse
of MEMBER SATISFACTION

NO MATTER THE INDUSTRY, IT'S A FACT THAT CONSUMERS ARE BETTER EDUCATED THESE DAYS.
They demand better service at lower prices, more access to accurate infor-
mation and faster problem resolution. Blue Cross and Blue Shield of Florida
(BCBSF) has always had a strong focus on its members. But to remain com-
petitive and increase our market share, we need an exact understanding of
what our members want and the factors that influence their health care
decision-making.

"With the company's strategic focus on members, market research has
taken on added importance," says Paul Barnes, vice president of Market
Research and Reporting. "We've been given a mandate to be the voice of our
members within the organization. To do that, we're creating a world-class
market research capability."

Market research, says Barnes, offers both quantitative and qualitative analy-
ses that can help us better satisfy our members and provide them with the
affordable health care choices they want. It also helps us measure our success.

CONTINUED ON NEXT PAGE

perspectives: corporate in-house magazine

The journal of this medical provider encourages
staff participation through its fresh, active design –
working for this company is not only a job, but a
lifestyle. Inspirational images combined with the use
of visual rhetoric make the magazine both
entertaining and accessible. The typographic display
of quotations provides an easy entry point to each
article, while injecting variety into the layout.

CORPORATE DIRECTION:
CHARTING OUR COURSE FOR THE FUTURE

FOCUS ON
Choice &
Affordability

WITHOUT IT, A COMPANY IS LOST. A "CORPORATE DIRECTION" SETS THE STAGE FOR THE FUTURE. It charts a company's course and brings its goals, branding and values to life. Not surprisingly, BCBSF's corporate direction is a hot topic of conversation throughout the company these days.

Throughout 1999, BCBSF focused its corporate direction work on clarifying its vision for our core health care business and developing that business sector's path to the future. This process resulted in a health care vision for the new millennium: to be the industry leader by providing affordable health care choices to Floridians.

Blue Cross and Blue Shield of Florida President and CEO Michael Cascone, Jr., believes we're on the right track: "We can help our members live confident, healthy lives and have a positive influence on the continuing evolution of our industry. The way we do this is to focus on choice and affordability — from our members' point of view."

Choice is what the future of health care is all about. Within choice, we're talking about choices in products, physicians, types of care and information for decision-making. A key element of choice is giving members the information they need to make "informed" choices that are best for them from their perspective.

Traditionally, we have put an internal focus on affordability. Today, and in the future, we know we must take a much broader view and think of affordability from our members' perspective. That means taking into account the total health care costs our members pay. These costs include all out-of-pocket expenses as well as the premiums they pay us. Because affordability varies with the individual, our products must be affordable to those who fall in between and on both extremes of the economic scale.

"The bottom line is that members want value," says Joe Grantham, senior vice president and chief strategy officer. "Even when the premium is affordable, the other associated costs make our members' health care too expensive and diminish our ability to provide affordable health care choices."

> "We can help our members live confident, healthy lives and have a positive influence on the continuing evolution of our industry. It comes down to providing [them] with caring solutions. The way we do this is to focus on CHOICE and AFFORDABILITY..."
>
> — MIKE CASCONE, JR.
> BCBSF PRESIDENT AND CEO.

Within this framework of strategic thinking, there is still much work to be done. "This year, we are focusing on two important areas: building the strategies in our health care business necessary to achieve the corporate direction we have established for this segment of our business, and building alignment for that direction throughout the organization," says Grantham. "Both of these elements are critical to our success and must be carried out simultaneously."

The strategy work is in progress under the leadership of Dr. Robert Lufrano, executive vice president of our health business. "To build the strategies we need to provide all Floridians — regardless of geographic location — with affordable choices," says Lufrano, "we are concentrating on five key areas: quality, service, product development, E-Commerce and organizational effectiveness."

- Our quality must be viewed as excellent by both our members and the marketplace. We can improve our positioning of quality through better segmentation and an integrated marketing mix (i.e., product, price, promotion, and distribution).

- Service includes not only what we do for our members, but also what the providers in our networks do for our members. Every contact our members have with the health care system needs to be brought to a level of excellence from their perspective. Consistent with service excellence, we also will focus on enabling our members to take responsibility for their own care.

- To improve our product development, we need superior market research capabilities to develop a deeper understanding of our members' needs, values and expectations. Our product development must move away from the "O's" (HMOs and PPOs) and focus more on "choice." As we develop our next generation of products, we need to think beyond our traditional focus of contract benefits, look at the product from a more member-focused, "end-to-end" perspective, and be more creative in managing medical costs.

- Our industry is information intensive and will become increasingly more so in the future. E-Commerce relates not only to using that

information more effectively and efficiently in the things we do today, but also in developing new applications and processes that will create value within our industry. Our E-Commerce strategy will largely be driven by how we address product quality, service and product development issues.

- Moving forward with our corporate direction requires significant change. To successfully transform our company and realize our vision, organizational effectiveness is essential. It encompasses the dimensions of people, process, leadership, structure and culture. Another important component of organizational effectiveness is information management — developing a comprehensive base of information along with the tools and people necessary to effectively use the information.

"Every employee plays an important role in helping our company successfully move along our course — or direction — for the future," says Senior Vice President Catherine Kelly. As strategy development continues, we also need to build alignment for our corporate direction throughout the organization. Kelly believes that "communication is a critical component of building alignment, but employees also need to proactively ask questions and develop a clear understanding of where our company is headed."

Formal and informal communications across the organization on corporate direction will be ongoing throughout 2000. Communications will include both information-sharing, such as this article, as well as interactive sessions to help employees understand, accept and commit to our company's direction and strategy. This article focuses on our health business sector. Future communications will address direction for our corporation as a whole.

Our senior leaders believe that setting strategic direction and developing corporate strategy are an important part of their responsibilities. They also agree the best chance for our company's continued success is to make sure all employees understand how important their work is as a member of the Blue Cross and Blue Shield of Florida team.

Says Cascone, "We're a team, dedicated to being a leader in Florida by providing caring solutions to our members."

'Can Do' Attitude:
RESPONDING
Quickly
TO MEMBERS

> "The biggest thing this project represents is:
> 'We can do it.
> We can change,
> and we can change quickly
> in order to do things
> our members want'."
>
> — MELISSA REHFUS
> VICE PRESIDENT OF PUBLIC POLICY AND CHAIRPERSON OF THE PUBLIC
> UNDERSTANDING CAMPAIGN TASK FORCE

"Actions speak louder than words"

is an accurate way to describe the company's new customer service solutions, which will debut in the fall.

Earlier this year, Blue Cross and Blue Shield of Florida implemented the first two phases of the Public Understanding Campaign, using extensive advertising to underscore what our members like about us and what we do well. To deliver on our customer promise, and to further differentiate us from the competition, BCBSF has launched Phase III of the campaign. It is here, in the third phase, that we will improve the total member experience and build confidence through a series of innovative business changes that respond directly to either real or perceived concerns.

"The biggest thing this project represents is: 'We can do it. We can change, and we can change quickly in order to do things our members want'," says Melissa Rehfus, vice president of Public Policy and chairperson of the Public Understanding Campaign Task Force.

Rebecca Westbrooke, project planning consultant in Human Resources and a task force member, says the focus is not legislative in nature.

"We want to make good business changes to improve our customer service and relationships with our members," Westbrooke says.

Collectively dubbed "Customer Solutions 2000," the phase-three initiatives have two purposes, according to Senior Vice President Larry Payne: "To focus new initiatives and efforts on our members, and to give employees the tools to better serve them."

The company will implement four significant business changes by early fall:

FIRST: External Review of Medical Necessity Denials for HMO Members. Previously, any such denials of care due to lack of medical necessity or an experimental nature have been reviewed by two BCBSF panels, both of which include physicians. But to assure members that such decisions are totally objective and based on medical rather than financial criteria, BCBSF will

CONTINUED ON NEXT PAGE

posters

Two of these three posters address the political issues of privacy and homelessness, while the central piece serves to promote the design group's own website. All three pieces weave type into the imagery to create compositions with both visual and verbal power: this integration reaches its zenith in the self-promotional piece, where three-dimensional characters are physically set alight.

Designers
Jason Grant, Robyn McDonald, Ben Mangan, Russell Kerr

Photographers
Jason Grant, Kevin Phillips

Design company
Inkahoots

Country of origin
Australia

Description of artwork
Posters

Dimensions
Various

NO VACANCY

NO VACANCY NO SHELTER NO HAVEN NO HARBOUR **NO HEART**

EVICTING THE HOMELESS

The squeeze is on. There's no place left to stay in the Sunshine State! Is housing a fundamental human right or a luxury for the privileged? Can we get our governments to secure this right for ALL citizens?

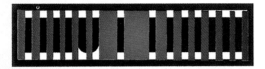

ANNI KUAN

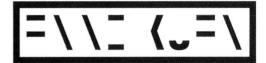

242 W 38TH ST NEW YORK NY 10018 PHONE 212 704 4038 FAX 704 0651

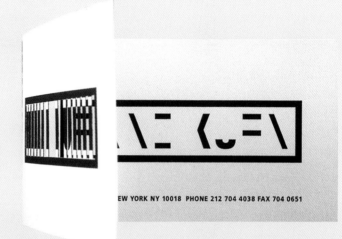

EW YORK NY 10018 PHONE 212 704 4038 FAX 704 0651

anni kuan: business card

New York fashion designer Anni Kuan's distinctive logo has been analyzed by the designer into its constituent parts: 14 vertical strokes printed on the outer diecut surface of the folding card; and six horizontal strokes, four oblique strokes, and one curve printed on the base of the card. Viewed individually, both surfaces are meaningless, but together they cleverly reveal her name.

Designers
Stefan Sagmeister,
Hjalti Karsson

Art director
Stefan Sagmeister

Design company
Sagmeister Inc

Country of origin
USA

Description of artwork
Business card

Dimensions
$3^{1}/_{2}$ x 2 in
90 x 50 mm

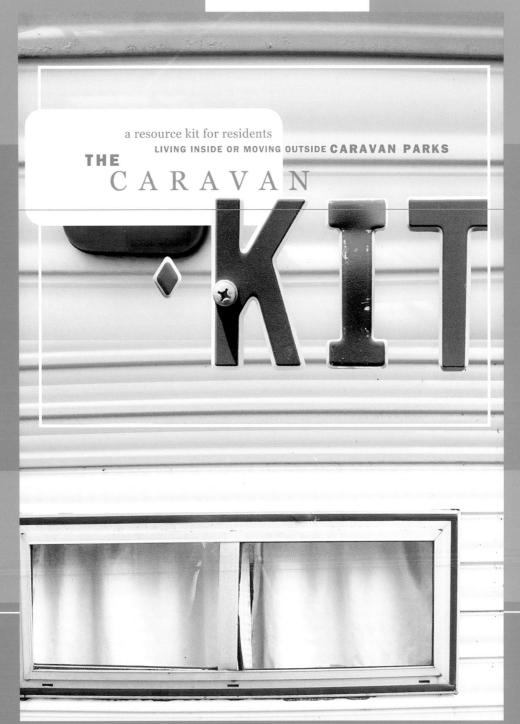

a resource kit for residents
LIVING INSIDE OR MOVING OUTSIDE CARAVAN PARKS
THE C A R A V A N
KIT

Designers
Jason Grant, Robyn McDonald, Ben Mangan

Photographers
Jason Grant, Chris Stanard

Design company
Inkahoots

Country of origin
Australia

Description of artwork
Book within information kit

Dimensions
8^1/$_4$ x 11^1/$_2$ in
210 x 297 mm

the caravan kit: book

The formed metal paneling of a caravan makes up the textural, almost abstract, image on this book cover. The type gives context to the image, and the use of a weathered licence plate, complete with fixing screw, creates the sense that this is a practical guide to life on the road.

projet mallarmé

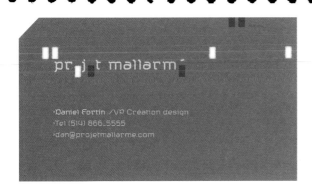

project mallarmé

·Daniel Fortin·/VP Création design
·Tel (514) 866_5555
·dan@projetmallarme.com

Works for both MEN AND WOMEN!

The quick brown tick jumped over the lazy humanoid vermin. The quick
brown tick jumped over the lazy humanoid vermin. The quick brown tick

perdez 10mg
en 7 heures

The quick brown tick jumped over the lazy
humanoid vermin. The quick brown tick jumped over
the lazy humanoid vermin. The quick
brown tick jumped over the lazy humanoid
vermin. The quick brown tick jumped over the lazy humanoid
vermin. The quick brown tick jumped over
the lazy humanoid vermin. The quick brown tick

ABCDEFGHIJKLMNOPQRSTUVWXYZ
abcdefghijklmnopqrstuvwxyz
1234567890@<$£¢¥>ÆßŒøÔ÷©™

QWERTYUIOPLKJ
*`$£¢¥>ÆßŒ****
1234567890-=****
qwertyuiop[]
asdfghjkl;*****
zxcvbnm,/****

Projet Mallarmé: corporate identity

The visual identity designed for this multimedia
production company uses the name of the French
poet Mallarmé to highlight the cultural and artistic
orientation of the organization: the punchcard
motif suggests the digital medium in which it
works. A font specially designed for the project is
based on a highly stylized version of Courier.

Designer
Eric Dubois

Art directors
Eric Dubois, Jean
Christophe Yacono

Creative directors
Daniel Fortin,
George Fok

Design company
Époxy
communication inc

Country of origin
Canada

**Description of
artwork**
Letterhead (far
left), compliments
slip (top right),
business card
(center), type
sample sheet
(above)

Dimensions
Various

PARK AV SO

FOURTH AV

BROADWAY

UNION SQ

UNIVERSITY PL

E 17 E 16 E 14 E 13 E 12 E 11 E 10

FIFTH AV

W 17 W 16 W 14 W 13 W 12 W 11 W 10

NYC project
(see also pp. 72–75)

The booklet is based on the designer's experiences in New York during a five-month internship at design studio 27.12 design ltd. Her impressions – a mixture of the frivolous and the moving – are recorded in a mixture of photography and type, the arrangement of which is often informed by the geography of the city itself.

PARK AV SO

Designer
Anne Ophardt

Photographer
Anne Ophardt

Design college
Fachhochschule für
Gestaltung, Darmstadt

Country of origin
Germany

Description of artwork
Limited edition booklet

Dimensions
4 x 7 1/2 in
105 x 190 mm

SQUIRREL

SQUIRREL

SQUIRREL

rollerb ading
SQUIRREL
joggen
footba l
frisby
roller-dancing
ice-skating
bicycling
walking

NO sports
YES reading
relaxing
sunbathing
daydreaming

Thank you

PLEASE HELP PROTECT THIS LAWN, TREES, BRIDGES, ZOO, FOUNTAINS, LAKES, HORSE-DRAWN CARRIAGES, DOGS,...

CENTRAL PARK

They got the airport, city hall, dance floor - they even got the police. Irish, Italians, Jews and Hispanics

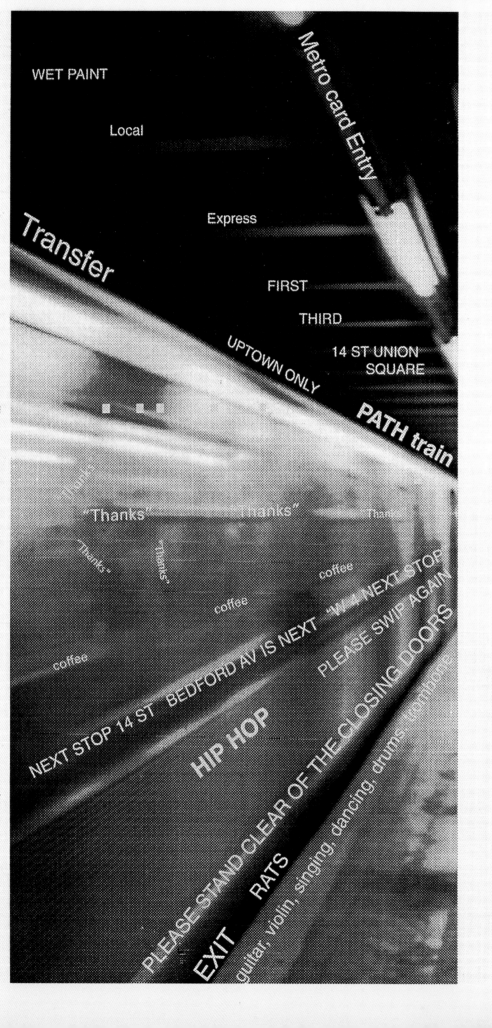

WET PAINT

Local

Metro Card Entry

Express

Transfer

FIRST

THIRD

UPTOWN ONLY

14 ST UNION
SQUARE

PATH train

"Thanks" "Thanks" "Thanks"

"Thanks"

"Thanks"

coffee

coffee

coffee

NEXT STOP 14 ST BEDFORD AV IS NEXT "NEXT STOP

PLEASE SWIP AGAIN

PLEASE STAND CLEAR OF THE CLOSING DOORS

HIP HOP

PLEASE STAND CLEAR OF THE CLOSING DOORS

EXIT RATS

guitar, violin, singing, dancing, drums

F L

united we stand

Oh, say can you see by the dawn's early light,
What so proudly we hailed at the twilight's last gleaming?
Whose broad stripes and bright stars thru the perilous fight,
O'er the ramparts we watched were so gallantly streaming?
And the rockets' red glare, the bombs bursting in air,
Gave proof through the night that our flag was still there.
Oh, say does that star-spangled banner yet wave
O'er the land of the free and the home of the brave?

On the shore, dimly seen through the mists of the deep,
Where the foe's haughty host in dread silence reposes,
What is that with the breeze, o'er the towering steep,
As it fitfully blows, half conceals, half discloses?
Now it catches the gleam of the morning's first beam,
In full glory reflected now shines in the stream:
'Tis the star-spangled banner! Oh long may it wave
O'er the land of the free and the home of the brave!

In GOD We Still Trust

red, white and blue
FLAGS EVERYWHERE!

① ② ③

Downtown & Brooklyn only

Houston	Lincoln	Center	Skyscraper	Brad		Big	Apple	Empire	State	Building	P				
Tiffany's	Tunnel	Station	Metropolitan	Met		Greenwich	Village	Central	Park	Broadw					
Museum	Harbor	Crowd	Sightseeing	Man		Queens	Manhattan	Stock	Exchange	Stu					
Stadium	Airport	Macy's	Homeless	Rad!		Guggenheim	Harlem				R				
Attitude	Tribeca	Island	Gramercy	Any		Statue	Liberty			Brooklyn					
Yonkers	Tavern	Upper	His	Fun	Open		Borough	Island			Giants				
Banking	Skyline	World	Off	Pot	Mor		Staten	Yankee	New York Talk						
Mugged	Winter	Knicks	Or	You	Fool		42nd	Street	Of	We	Love	Brownout	F		
Pollution	Tourist	Strike	Old	Suit	Mus		Madison	Square	Garden	New York	C				
Belmont	Murder	Crime	By	Bills	Trac		Rangers	La Guardia	Wall	Zoo	The	Bro			
Walk-Up	Market	Lower	My	Day	Mou		Center	Melting			Parade	5			
Beautiful	Towers	Token	Far	Yell	Littl		Letterman	Train	Hall	A	Cab	Carneg			
Islanders	Theatre	Ballet	St.	Life	Loca		Hudson	River	Ellis	Chinatown	Chelsea				
: @	ly	ing	For	NY	A	in	Saw	Time		Walt	Plaza	Away	Saks	Tour	Twin
; ?	ly	ing	Him	Of	A	To	East	Post		Fight	With	Blue	Stop	Good	This
" I	If	est	She	At	's	To	Fare	NBC		Shea	Sleep	Food	Ball	Work	Side
" &	In	He	Her	At	's	It	Late	CBS		Toll	Poor	Sing	Bad	Walk	Visit
s ,	es	ies	The	As	I	It	That	ABC		Hate	Show	Dress	Rent	West	Jazz

september

september

september

september

september 11
osama bin laden

missing

twins

missing

missing

september 11
osama bin laden
missing
twins
missing
god bless america
victims of september 11
missing
ground zero
wtc RIP
missing
bush
terrorism
afghanistan
firemen
missing
heroes
missing
american airlines
missing
anthrax
missing
rudy giuliani
person of the year
proud to be american
missing

missing

missing
war
missing
tora bora
missing
new york fire fighters
america strikes back

missing
heroes

missing
american airlines

missing

missing

11

september

11

11 11 11 11 11 11

11 11

11

missing

missing

missing

missing

433 HUDSON STREET, 8TH FL.

MEREDITH

MARY ANNE

JESSICA

JEREMY

27.12 Design LTD
book jackets & interiors, design consulting, music packaging, product development, branding, art direction

In New York you can forget - forget how to sit still

SWEATER, CORDUROY, LEATHER BAG, SUNGLASSES, I DON'T REMEMBER, "BROOKLYN SWEATER", NO MAKE-UP, HAT, JEANS & SWEATER, CELLPHONE

ONE TIME, ONE TIME, ONE TIME, FIVE TIMES, ONE TIME, ONE TIME, FOUR TIMES

Ethan Hawke, Susan Sharandon, Jeremy Irons, Monica Lewinsky, Debra Winger, Arliss Howard, Harrison Ford.

film premier, near, almost in the office, in the corridor

at ground zero on the street, "grey dog", at a film premier,

on the street, st-second avenue, "petite abeille",

You can't walk around the block without a change of clothing

tower-blocks pulsating
against the night sky

tenemented stone
a beautiful shell
ironwork, scaffold sandstone
buildings stride high
ever upward

urban artwork
the people the words

city life

sky

of human proximity
of settlement
ground centre
network cross
columns - the mercat
organic grid
and
identity

the urban canopy
long broad streets
shine after ra
see it as a living

breathir

the city is always there
pulsing alive

never truly resting

where words
fall effortlessly
lost forever

until now..

STREET TALK
WORDS ON GLASGOW

HE PAT

EET WO

AT VO

WHIT YOU

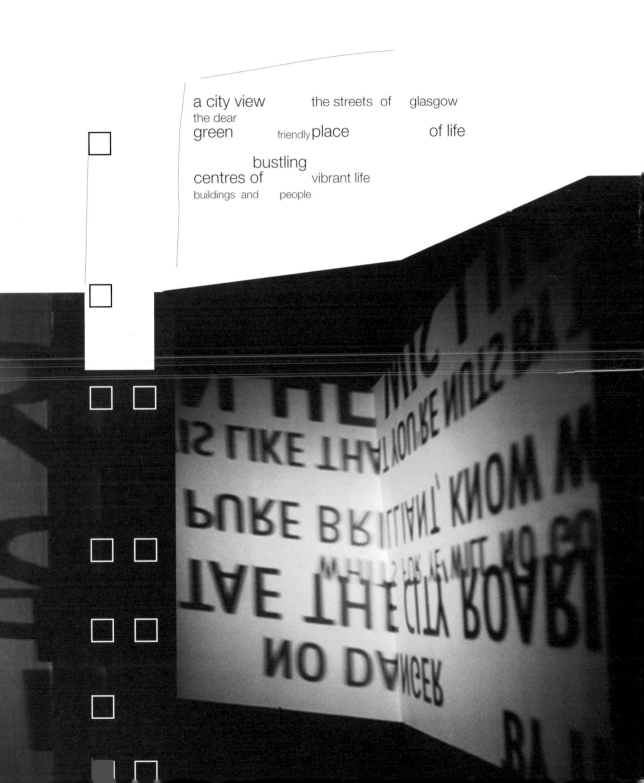

a sense of place: composition (see also pp. 78–79)
The brief for this student project was to produce a piece
of purely typographic work exploring and describing a
place of particular personal significance. The designer
has responded by building a profile of the living city from
words – colloquialisms and overheard snippets of
conversation – which are "mapped out" on the built fabric
of Glasgow. Phrases appear as if projected, giving the
feeling of a busy city at night – hoardings briefly
illuminated by passing headlights. The approach harks
back to the "concrete poetry" experiments of the 1960s.

:h its

:he city

organism

ver silent

a city view the streets of glasgow
the dear
green friendly place of life

bustling
centres of vibrant life
buildings and people

Designer
Niall Young

Tutor
Rhiannon Robinson

Design college
Cumbria College of Art
and Design

Country of origin
UK

Description of artwork
Fold-out poster

Dimensions
11^1/$_2$ x 16^1/$_2$ in
297 x 420 mm

the word on the street
i've got a mooth like a
says this yin
pocketful o' dowts
no
pure
is pure sharp
gallus - to be deid gallus
gallus

the people but i've got a mooth
double wide
double but

disnae work but

the people

in this
the trouble
wi rhyming slang in this

a valid regiona
r
categorising it a
insisting that lar

our lingustic pre

disnae work

double double

pure
whit's goin on

in this
the trouble
w

valid regional dial
pure dead bri

THE PATT
'MON THE CELTIC!
OTED
STREET TA
N' ON WI

'A FER BY THE
HAD TAE F
OW WHAT I MEAN
REET WORD
IS LIKE
THEN I WIS LIKE THAT

the trouble
place is wi rhyming slang in this
make it the folk who
up as they

go along

alect
rkable sense of humour "the patter"
derivative
ge is a sound system and that

ceptions of
good and bad are class based

the people

pure

rhyming slang work but

the

street

rhyming slang in this

gallavantin

ith its own unique growth

but

and left

without nane

but

nane

to be deid gallus is pure sharp
word on the street is double wide
wee guy's

double wide
double wide

disnae work
oo- gallavantin

and left

BY THE WAY
BIGOT
REET TAD

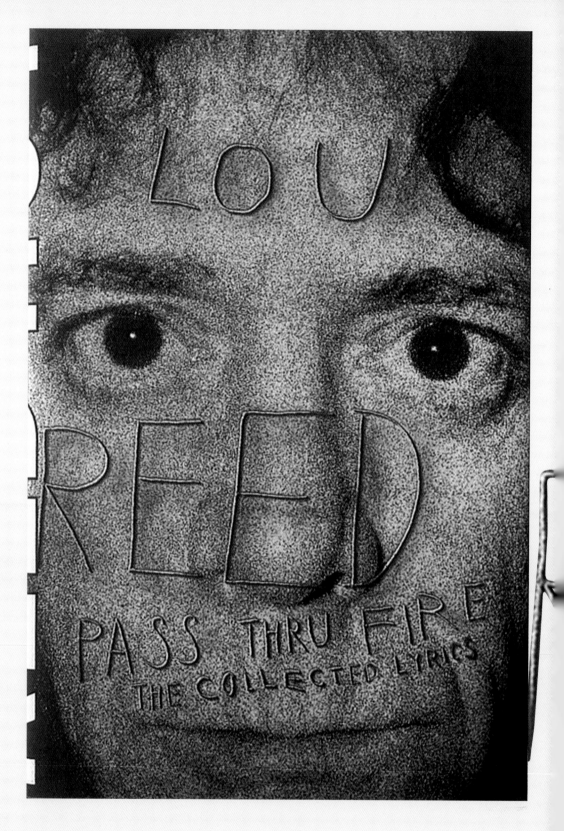

pass thru fire: book

This Lou Reed anthology collects together lyrics from all the artist's albums – one chapter for each album. The steadiness and simplicity of Reed's work is reflected by the use of one single typeface throughout the book, although each chapter has its own distinctive typographic style, mirroring the mood and feel of the words and music. The cover features a self-portrait of the artist, overlaid with embossed type.

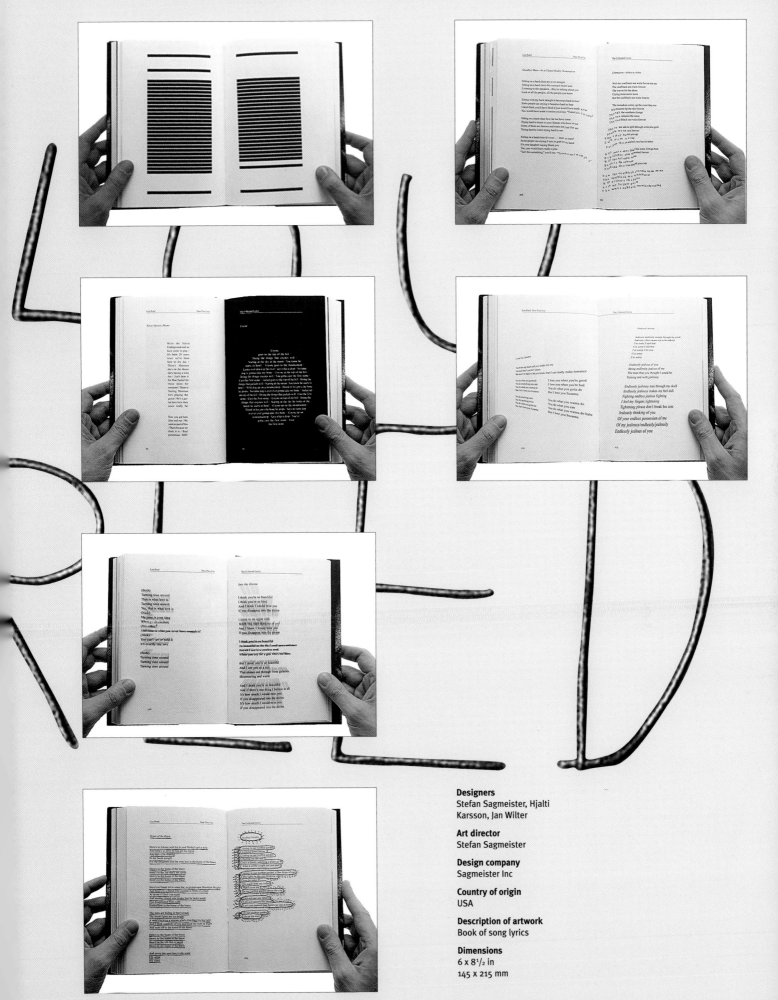

Designers
Stefan Sagmeister, Hjalti
Karsson, Jan Wilter

Art director
Stefan Sagmeister

Design company
Sagmeister Inc

Country of origin
USA

Description of artwork
Book of song lyrics

Dimensions
6 x 8 1/2 in
145 x 215 mm

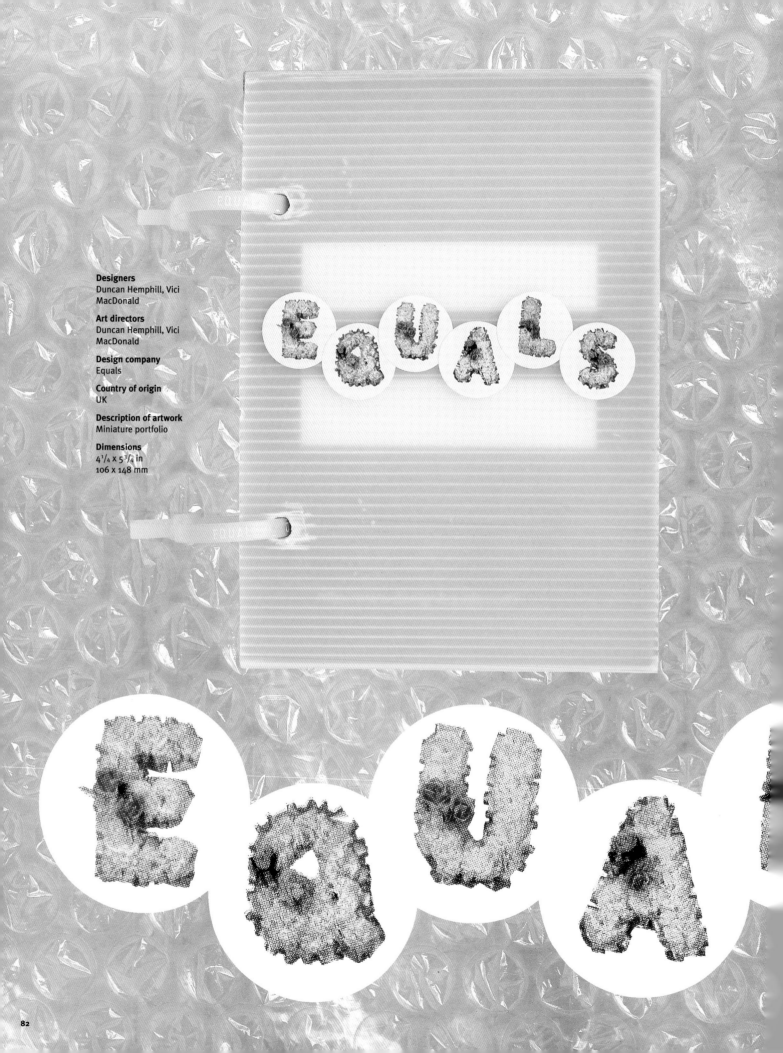

Designers
Duncan Hemphill, Vici
MacDonald

Art directors
Duncan Hemphill, Vici
MacDonald

Design company
Equals

Country of origin
UK

Description of artwork
Miniature portfolio

Dimensions
4 1/4 x 5 3/4 in
106 x 148 mm

Routledge Books
Book covers:
psychology + philosophy + culture
We have created many covers for these Routledge lists, often with sensitive or non-visual subject matter. Usually there is no picture budget (or a mandatory author-supplied image), with only one colour plus black allowed. Whatever the constraints, we always try to create powerful solutions, using self-generated imagery, strong typography and interesting print processes.
Hannah Arendt drawing: author-supplied

EQUALS www.designequals.com American poetry

Routledge Books
Media Handbook series identity
This series, aimed at media graduates, required updating. Authors sometimes provided the imagery, so a system of four photographic details ensured coherence. The backs and spines (bottom row) could fit varying text lengths and continued the theme. When we were given a free hand, as below, a mini photo-essay was created.
Previous identity

EQUALS www.designequals.com Exhibition catalogue and floor plan

Australian Beach House Company
Corporate ID: logo + stationery
This New South Wales specialist in luxury beachfront rentals needed a relaxed, upmarket image. The striped stationery – an abstract of sand, surf and sea – is on translucent paper and looks different from front and back (far and near left). The logo, with a tiny starfish dot over the Y, is echoed on stickers and packaging ribbon (bottom).

EQUALS www.designequals.com Brochures for beach bums

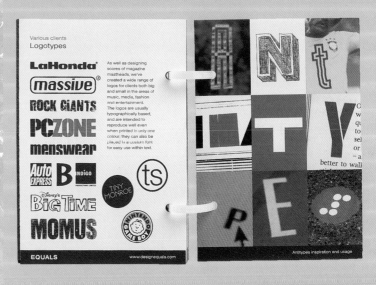

Various clients
Logotypes
As well as designing scores of magazine mastheads, we've created a wide range of logos for clients both big and small in the areas of music, media, fashion and entertainment. The logos are usually typographically based, and are intended to reproduce well even when printed in only one colour; they can also be placed in a custom font for easy use within text.

EQUALS www.designequals.com Antitypes inspiration and usage

equals: miniature portfolio
The cover of this design company portfolio is made from corrugated translucent plastic. Each letter of the company name is printed on its own white self-adhesive disc, and positioned by hand on the cover, instantly personalizing every mailing. Each portfolio spread features a full-bleed image on the right, which complements the work displayed on the left. The restrained typography within allows the work to speak for itself.

chive: identity system

The visual identity produced for this San Diego restaurant and bar makes distinctive use of numbers to substitute for letters. This contributes to the wit and quirky freshness of the design, which is stylish yet simply produced.

Designers
Don Hollis,
Gina Elefante

Art director
Don Hollis

Design company
Hollis

Country of origin
USA

Description of artwork
Invitation packaging (left), sticker (top), gift token (top right), coaster (center), invitation (right).

Dimensions
Various

Eco-Fund
promoting environmental harmony

FORESTERS ANA
FRIENDLY SOCIETY
real ethical investment since 1890

brochures and poster

The covers of brochures for Foresters ANA (right), Australia's oldest ethical investment company, employ a series of abstract images of consistent color to identify different financial products. The company logo is isolated by using a contrasting, but similarly muted color. The public information poster (far right) uses a strong hue of red to signify danger; the word "safe" is thrown into relief on the background by use of negative space around the characters, setting up a dynamic between the message of alarm and the information needed to avoid danger.

Ethical Bond
an opportunity for practical idealists

FORESTERS ANA
FRIENDLY SOCIETY
real ethical investment since 1890

Ethical
Superannuation
Fund
the fund for practical idealists

FORESTERS ANA
FRIENDLY SOCIETY
real ethical investment since 1890

WHAT TO DO IF YOU FIND
USED
SYRINGES

FURTHER INFORMATION
CLEAN NEEDLE HELPLINE
1800 NEEDLE
1800 633 353

Do NOT attempt to recap the needle

Find a rigid-walled, puncture-resistant, sealable container

Find and put on latex/rubber gloves if possible

Bring the container to the needle/syringe

Place the container on the ground beside the needle/syringe

Do not hold the container upright in your hands as you are disposing of the needle/syringe

Pick up the needle/syringe by the middle of the barrel

Keep the sharp end of the needle/syringe facing away from you at all times

Place the needle/syringe in the container sharp end first

Securely place lid on the container, holding the container at the top

Remove gloves (if appropriate) and wash hands with running water & soap

Place the sealed container into rubbish, or return it to your nearest Needle & Syringe Program (NSP) for disposal as medical waste

Other items that have come into contact with blood should be disposed of in the same container as the used needle/syringe, or placed into double plastic bags and then into rubbish, or taken to a NSP for disposal

Advise children to inform an adult if they find unsafely disposed of needles/syringes

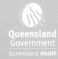

Queensland
Government
Queensland Health

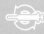

Produced by Queensland
Needle & Syringe Program
© Queensland Health (November 2001)

Designers
Jason Grant, Robyn
McDonald, Ben
Mangan

Design company
Inkahoots

Country of origin
Australia

Description of artwork
Brochures (left) and poster (right)

Dimensions
Brochures (unfolded)
11^1/$_2$ x 8^1/$_4$ in
297 x 210 mm
Poster
11^3/$_4$ x 19^1/$_2$ in
300 x 500 mm

studies for the orange project (see also pp. 90–91)
This experimental piece juxtaposes terms used in music notation, judo, and fencing with images of flowers and empty space. The typeface Corporatus was designed specifically for this work, and helps to build the impression of a surreal, disconnected world, where the sound of the word, rather than its actual meaning, has particular significance. The pieces become almost objects of meditation – the words typographic mantras. This type of experimentation can reveal powerful combinations of images and words – a technique commonly used in advertising.

RIVERSA

Designer
Bob Aufuldish

Photographer
Bob Aufuldish

Design company
Aufuldish & Warinner

Country of origin
USA

Description of artwork
Experimental magazine pages demonstrating use of Corporatus typeface

Dimensions
7 x 10 in
178 x 254 mm

SEIRYOKU ZENYO

FORTE

SUSPENDED SEVENTH

KUZUSHI

FEINT

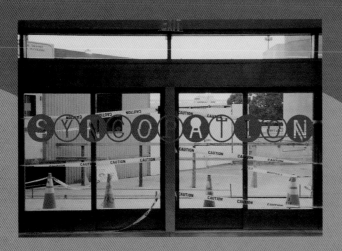

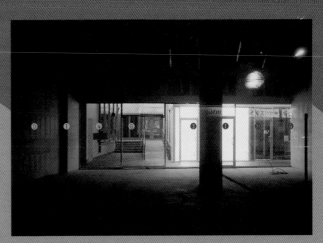

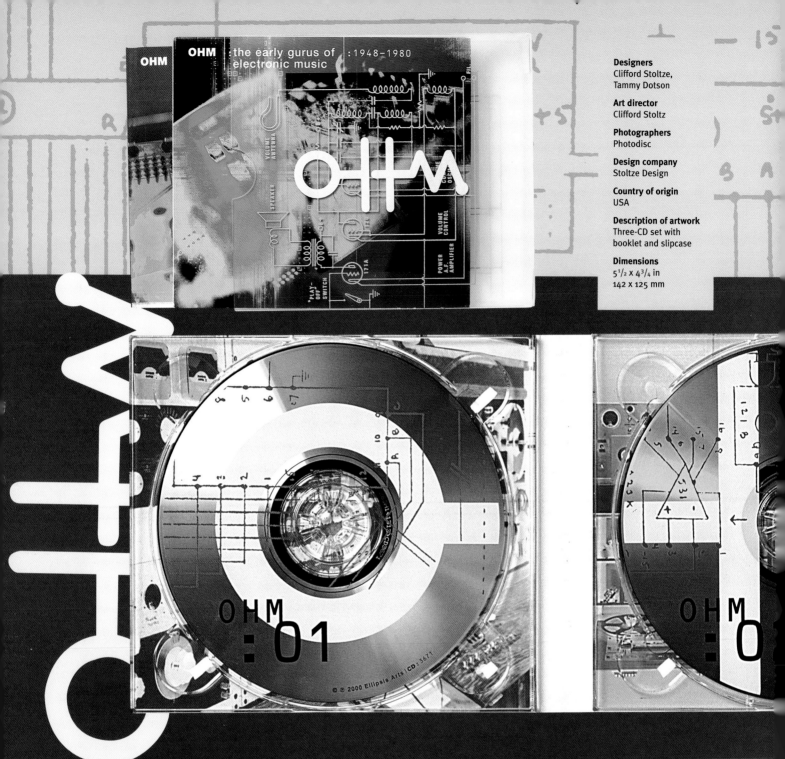

Designers
Clifford Stoltze,
Tammy Dotson

Art director
Clifford Stoltz

Photographers
Photodisc

Design company
Stoltze Design

Country of origin
USA

Description of artwork
Three-CD set with
booklet and slipcase

Dimensions
$5^{1}/_2$ x $4^{3}/_4$ in
142 x 125 mm

OHM : the early gurus of :1948–1980
electronic music

early gurus of electronic music: cd packaging

This three-CD set, together with booklet and slip case, explores the development of electronic music from 1948 to 1980. The packaging, designed with intricate patterns of connecting lines, circles, and squiggles that resemble bolts of electrical activity between two conductors, was intended to suggest the inner workings of an electrical device, possibly a musical instrument. This theme is carried over to the surface of the CDs themselves. Even the cool typography of the accompanying booklet is punctuated with simple graphics that recall circuit diagrams.

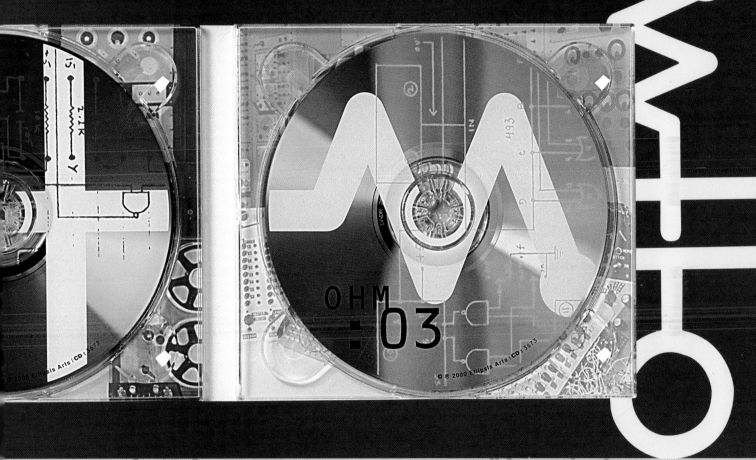

OHM
:03

WHO

:01

Track 01
Clara Rockmore
(1911–1998, United States/Russia)
Tchaikovsky: "Valse Sentimentale"
(2:08), 1977
From: *The Art of the Theremin* (Delos)

Clara Rockmore first met Leon Theremin in 1928 in New York City. She was a teenaged violin virtuoso from Russia. Theremin also had come from Russia. Lenin himself had dispatched the young musician-physicist-inventor to the decadent, capitalist West to demonstrate the electrical marvels emanating from the newly formed Soviet Union. In quick succession, Rockmore became Theremin's student, his protégée, and then the world's foremost exponent of the space-controlled musical instrument that bears his name. Rockmore performed as soloist in over a hundred concerts with major symphony orchestras, and she and her pianist-sister Nadia Reisenberg performed countless recitals over a five-decade period. "Valse Sentimentale" was in the repertoire that the two sisters played regularly. This performance is taken from recordings that the sisters made around 1976 and that are now available on CD (Delos D/CD 1014).

—Robert Moog, producer and creator of the Moog synthesizer

:02

Track 02
Olivier Messiaen (1908–1992, France)
"Oraison" (7:42), 1937
From: *Toussaint, Murail, Prévost, Messiaen, Vivier* (SNE) Performed by Ensemble D'Ondes De Montreal, 1996

"Oraison" was not the first all-electric work for the concert stage. It did, however, represent the first time a composer of this stature had devoted a whole piece to electrically produced sounds. The ondes martenot (a keyboard using a ribbon and ring to change pitch) had enjoyed a flavor-of-the-month popularity among European (especially French) composers in the late 1920s and early 1930s, but these composers all used the instrument as a new addition to the orchestral palette, exactly as its inventor, Maurice Martenot, intended it to be used. It was Messiaen, the mystic and organist, who kept something unique in the instrument and decided to write a piece for a whole ensemble of ondes martenot, without trying to meld it to potential acoustic instruments. The gliding, swaying sounds of the instruments create a mysterious, perhaps suspended, atmosphere that reflected Messiaen's mystical leanings perfectly.

—John Schaeffer, host of *New Sounds* on WNYC-FM, New York

Clara Rockmore playing the theremin

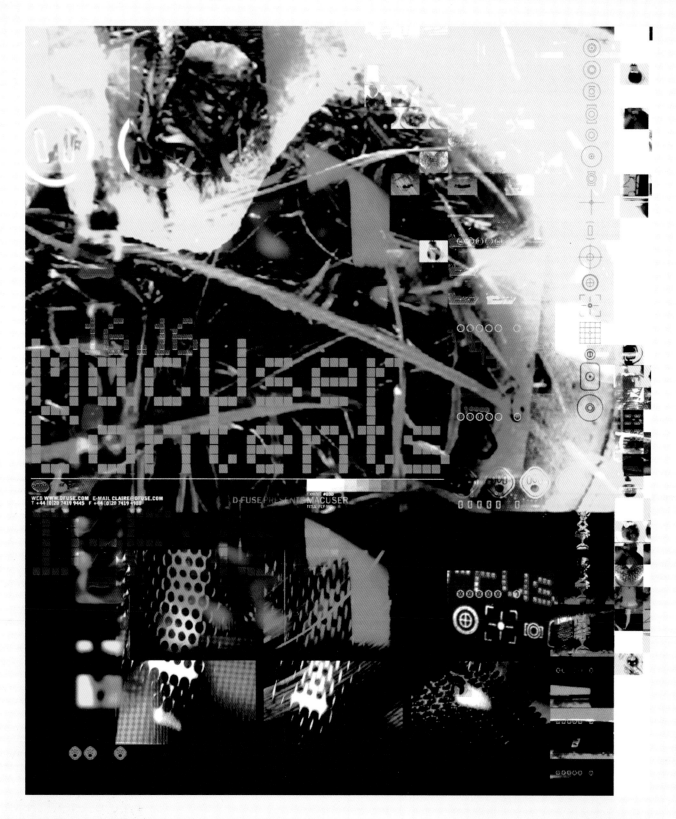

macuser and playstation 2: magazine pages

A fusion of video samples and type creates the edgy, hi-tech moods of these magazine pages. Type constructed from visible pixels, almost merging into the background image, forms part of the composition of the contents spread in MacUser (above). Deliberate camouflaging of the type in both pieces assumes that the reader has sufficient knowledge to decode the message, so helping to build the notion of the brand as an exclusive club.

Designers
D-Fuse

Art director
Michael Faulkner

Photographers
D-Fuse

Design company
D-Fuse

Country of origin
UK

Description of artwork
Page of contents spread in MacUser (above). Spread for Playstation 2 magazine (right)

Dimensions
MacUser
$8^{1}/_{4}$ x $11^{1}/_{2}$ in
210 x 297 mm
Playstation
$11^{1}/_{2}$ x 9 in
297 x 230 mm

WE SHOW YOU THE
FUTURE OF PLAYSTATION 2

Designer
Elizabeth Roberts

Illustrator
Elizabeth Roberts

Photographer
Elizabeth Roberts

Country of origin
Germany

Description of artwork
Poster

Dimensions
11³/₄ x 16¹/₂ in
300 x 420 mm

eat chinese: poster
This bold poster, printed on rice paper, forms the center spread
of a self-promotional brochure, which catalogs the designer's
collection of fortune cookie sayings.

Designer
Elizabeth Roberts

Country of origin
Germany

Description of artwork
Limited edition posters

Dimensions
23^1/$_2$ x 32^3/$_4$ in
600 x 840 mm

uzkár: posters

These hand-printed posters for a series of electronic music entitled uzkár (Hungarian for "poodle"), employ simple silhouette imagery and a consistent logotype to help establish the brand.

Department of Land Administration **New Horizons**

New Horizons

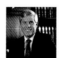

Minister's Foreword

There are few areas of Western Australia's vibrant economy that do not rely on land and land information for continued growth.

Security of land ownership underpins capital borrowing and new investment. Increasingly, land information is being used to help manage the environment, resources development, primary industries and the delivery of key services.

Indeed, in our information economy land information is as much an essential infrastructure as telecommunications, transport and utilities.

The Department of Land Administration's strategic plan reflects the Government's commitment to an environment in which Western Australian business can compete globally and plan confidently for the future.

By achieving the goals set out in this plan, DOLA will contribute to the prosperity and quality of life of all Western Australians.

Doug Shave, MLA

Minister for Lands

New Horizons

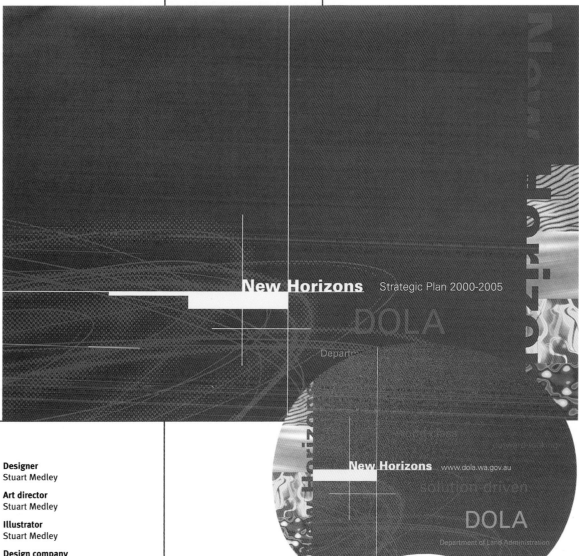

Designer
Stuart Medley

Art director
Stuart Medley

Illustrator
Stuart Medley

Design company
Lightship Visual

Country of origin
Australia

Description of artwork
Folder (top left), newsletter
(left and top right), and
mouse mat (right)

Dimensions
Various

new horizons: corporate identity

The launch of this newsletter forms part of the rebranding of a
government department in Western Australia, and marks a shift in
the internal and external perceptions of the organization's work.
The depiction of the title "New Horizons" as the rising sun is a
clear signal of the department's intention, and the use of color
that evokes sun and earth roots the initiative firmly in the region.

LAURELWOOD APARTMENTS (1949)
11836–11837 Laurelwood Drive, Studio City

Schindler arranged twenty nearly identical two-bedroom apartments very cleverly on this site which slopes both up and down. The one-story units are arranged in two levels on either side of a central path leading past the garage courts. The ground level units all have patios, while the upper level units have roof decks. Schindler angled the units as they step up the hill so that each two-unit block has a distinct front garden and entry area, and the living rooms as well as one bedroom in each unit have corner windows. Where the units step back down the hill, Schindler mirrored the floorplans rather than simply repeating them, so that the central path widens at both ends and all living rooms face the downhill view. Inside, varying ceiling heights, materials and textures distinguish the spaces.

KINGS ROAD HOUSE (1921)
835 North Kings Road, West Hollywood

This house for two families was Schindler's first independent design built in Los Angeles. It sits on a nearly flat large site, hidden from the street by a high bamboo hedge. The social program for the house was as radical as the design. Two families occupied separate wings with large multi-purpose spaces for each adult and rooftop open sleeping porches; they shared a kitchen. The outdoor living spaces were as important as the interior ones. The house was also a center of avant-garde artistic circles in Los Angeles.

The house is organized as three L shapes, arranged in a windmill pattern. Each family's pair of studios forms an L which wraps around an outdoor living space (which is further enclosed by walls of hedge and bamboo); the third L is formed by the kitchen, guest studio and garage. The studios have walls of concrete at the back and are open through glazing and sliding canvas doors to their outdoor room. Entry, bathrooms and storage are at the knuckle of the L, with a sleeping porch above. Each studio and the two large outdoor spaces are anchored by a fireplace.

Schindler lived and worked in this house for over 30 years, sharing the residence with others including the Richard Neutra family. Much in this house set the pattern for Schindler's work in Los Angeles. Private indoor and outdoor spaces are concealed from the exterior. The front door opens into a small hall at the knuckle of the L with a door-height ceiling. From here, there is a long diagonal view of the private garden. The hall opens onto both studios, which have higher ceilings and clerestory windows above the door-height datum. Door-height beams, tying the concrete and glazed walls together, also serve to articulate the studios into separate zones, as do door-height overhangs and glazed nooks projecting into the gardens. Schindler used the 'lift-slab' construction that had been pioneered in Southern California by architect Irving Gill in the 1910s for the concrete walls, and chose to expose the nature of this method in the vertical glass slots, which also let light into the interior.

GOLD HOUSE (1941)
3758 Reklaw Drive, Studio City

This house, at least in part a response to its irregular site, employs two intersecting geometries rotated 45 degrees from each other forming a splayed L that defines a private patio to the rear of the house. The geometries are also largely defined volumetrically with a gable roof over the living space intersecting the essentially flat roofs elsewhere in the house. Here, the intersections between the two are not all buried in service spaces; both bedrooms and the dining space are pentagonal, taking on both geometries. In contrast to the largely stucco exterior, the interior is articulated with wood and plaster. A lower level contains the garage, den and maid's room. Entry is made, from an exterior stair, into the corner of the living room, facing diagonally across to the fireplace.

The house employs the "Schindler frame" — a framing technique that establishes wall studs at typical door height, allowing room heights to vary and creating a continuous horizontal datum.

LINGENBRINK SHOPS (1950)
12634–12672 Ventura Boulevard, Studio City

For William Lingenbrink, who was also the client for the Modern Creators Shops in Hollywood, Schindler designed and remodeled a group of stores on Ventura Boulevard. Unlike the Modern Creators Shops, which were designed and built together as a coherent group of new buildings, these stores were built and altered over a fairly long period. They do not have the complex sectional development of the group in Hollywood, but Schindler again used large L-shaped stucco planes and prominent display cases to make the store facades more three-dimensional and dynamic.

MODERN CREATORS SHOPS (1938)
8766 Holloway Drive, West Hollywood

This small row of shops in West Hollywood gets the full Schindler treatment with its space forms, angled display windows and complex interior sections. The corner shop is chopped in plan to face the corner of the street. The roof, an inverted gable, swoops up over the mezzanine. The middle stores have a mezzanine at the rear overlooking their two-story spaces; the double-sloping roof is split at the center to provide clerestory illumination. At both the middle and end stores, the display cases form angled volumes projecting out from the main blocks. At the lot-line a large L-shaped wall interlocks with the last one-story shop to close the composition.

*Please refer to your itinerary for parking instructions for each of the tour sites; shuttle bus service is provided in areas where on-street parking is difficult.

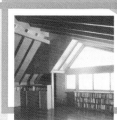

A DAY-LONG, SELF-DRIVEN TOUR OF ARCHITECTURE BY R.M. SCHINDLER

Designers
Brad Bartlett, Danielle Foushee

Art director
Brad Bartlett

Photographer
Grant Mudford

Design company
Turnstyle Design

Country of origin
USA

Description of artwork
Invitation (left), brochure (above), and tickets (far right) for an architectural tour

Dimensions
Various

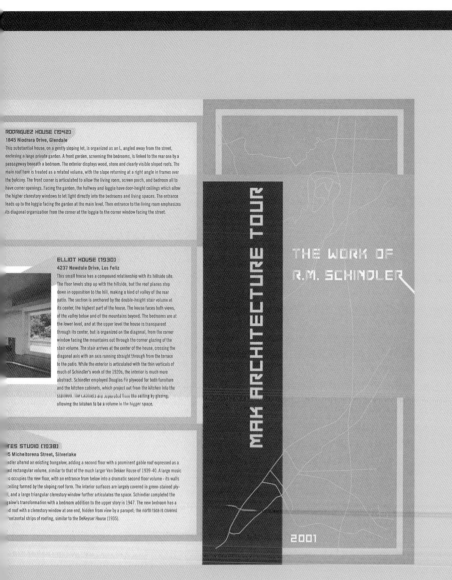

RODRIGUEZ HOUSE (1942)
1845 Niodrara Drive, Glendale

This substantial house, on a gently sloping lot, is organized as an L, angled away from the street, enclosing a large private garden. A front garden, screening the bedrooms, is linked to the rear one by a passageway beneath a bedroom. The exterior displays wood, stone and clearly visible sloped roofs. The main roof here is treated as a rotated volume, with the slope returning at a right angle in frames over the balcony. The front corner is articulated to allow the living room, screen porch, and bedroom all to have corner openings. Facing the garden, the hallway and loggia have door-height ceilings which allow the higher clerestory windows to let light directly into the bedrooms and living spaces. The entrance leads up to the loggia facing the garden at the main level. Then entrance to the living room emphasizes its diagonal organization from the corner at the loggia to the corner window facing the street.

ELLIOT HOUSE (1930)
4237 Newdale Drive, Los Feliz

This small house has a compound relationship with its hillside site. The floor levels step up with the hillside, but the roof planes step down in opposition to the hill, making a kind of valley of the rear patio. The section is anchored by the double-height stair volume at its center, the highest part of the house. The house faces both views, of the valley below and of the mountains beyond. The bedrooms are at the lower level, and at the upper level the house is transparent through its center, but is organized on the diagonal, from the corner window facing the mountains out through the corner glazing of the stair volume. The stair arrives at the center of the house, crossing the diagonal axis with an axis running straight through from the terrace to the patio. While the exterior is articulated with the thin verticals of much of Schindler's work of the 1920s, the interior is much more abstract. Schindler employed Douglas Fir plywood for both furniture and the kitchen cabinets, which project out from the kitchen into the stairwell. The cabinets are supported from the ceiling by glazing, allowing the kitchen to be a volume in the bigger space.

TES STUDIO (1938)
5 Micheltorena Street, Silverlake

...ndler altered an existing bungalow, adding a second floor with a prominent gable roof expressed as a ...ed rectangular volume, similar to that of the much larger Van Dekker House of 1939-40. A large music ...o occupies the new floor, with an entrance from below into a dramatic second floor volume - its walls ...ceiling formed by the sloping roof form. The interior surfaces are largely covered in green-stained ply-..., and a large triangular clerestory window further articulates the space. Schindler completed the ...galow's transformation with a bedroom addition to the upper story in 1947. The new bedroom has a ...d roof with a clerestory window at one end, hidden from view by a parapet; the north face is covered ...horizontal strips of roofing, similar to the DeKeyser House (1935).

MAK ARCHITECTURE TOUR

THE WORK OF R.M. SCHINDLER

2001

architectural tour: promotional pieces

These printed materials announce a celebration of the work of Austrian-born architect Rudolf M Schindler, who worked on the West Coast of the US from 1913 to 1953. The guide (above) interprets eight of the architect's most notable projects: the extensive use of rules and delineated areas mirrors the architect's own preoccupation with space and light. The display typeface used throughout is based on lettering designed by the architect himself; paired with sans serif text faces, it creates visual resonances with the European modernist movement.

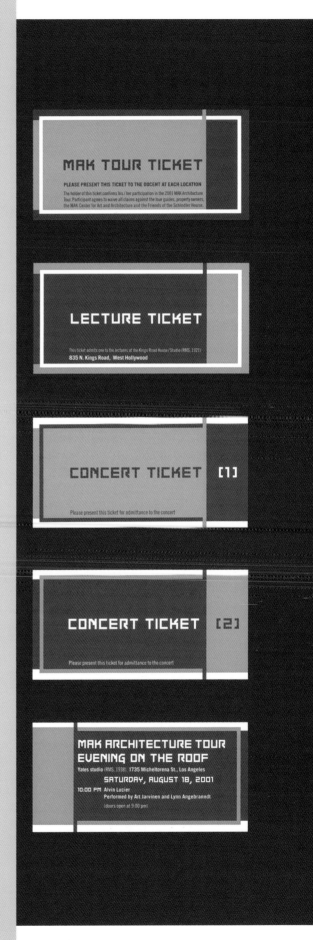

MAK TOUR TICKET

PLEASE PRESENT THIS TICKET TO THE DOCENT AT EACH LOCATION

The holder of this ticket confirms his / her participation in the 2001 MAK Architecture Tour. Participant agrees to waive all claims against the tour guides, property owners, the MAK Center for Art and Architecture and the Friends of the Schindler House.

LECTURE TICKET

This ticket admits one to the lectures at the Kings Road House / Studio (RMS, 1921)
835 N. Kings Road, West Hollywood

CONCERT TICKET [1]

Please present this ticket for admittance to the concert

CONCERT TICKET [2]

Please present this ticket for admittance to the concert

MAK ARCHITECTURE TOUR EVENING ON THE ROOF
Yates studio (RMS, 1938). 1735 Micheltorena St., Los Angeles
SATURDAY, AUGUST 18, 2001
10:00 PM Alvin Lucier
Performed by Art Jarvinen and Lynn Angebranndt
(doors open at 9:00 pm)

anni kuan: fashion brochure

The execution of this brochure demonstrates that creativity of the highest calibre does not depend on budget. The brochure itself is reproduced on newsprint, folded over cheap wire coat hangers, and shrink-wrapped in cellophane, just like the garments it promotes. The type is an integral part of the atmospheric and inventive monochrome images, and the piece as a whole transcends the print medium, itself becoming a desirable artifact.

Designer
Stefan Sagmeister

Illustrator
Martin Woodtli

Photographer
Tom Schierlitz

Design company
Sagmeister Inc

Country of origin
USA

Description of artwork
Fashion brochure

Dimensions
20 x 15¹/₂ in
510 x 395 mm

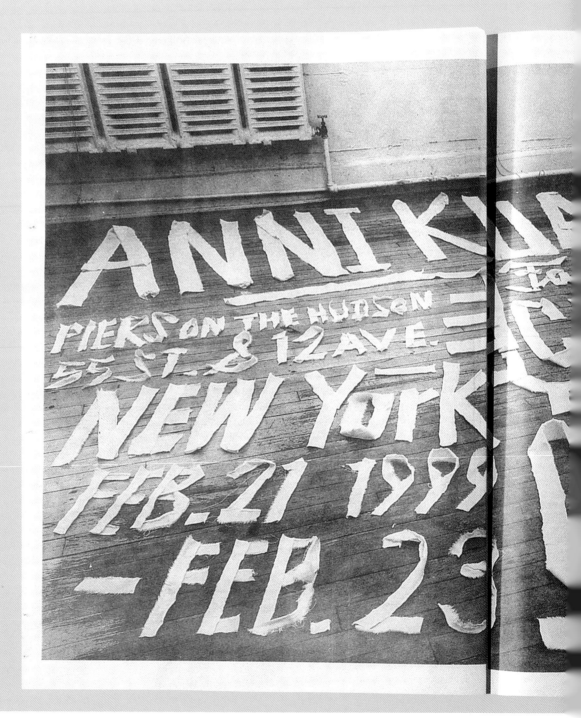

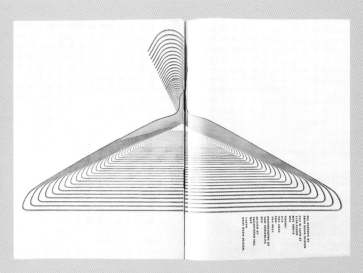

SILVER LACE SLIP DRESS IN STRETCH LACE
60% NYLON 40% VISCOSE

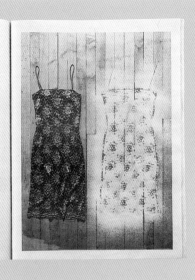

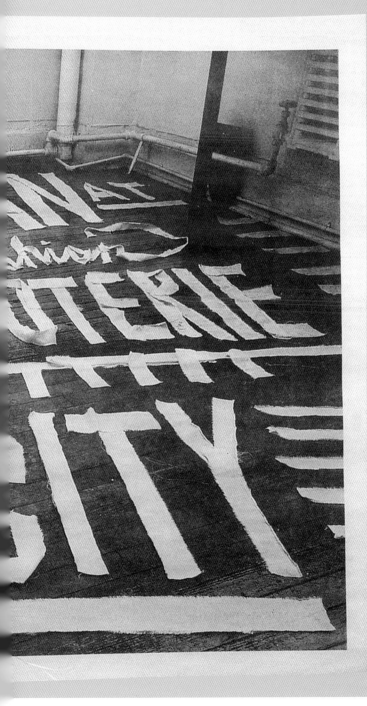

PREVIOUS SPREAD:
RED MAXI DRESS IN MATTE JERSEY 100% RAYON
WITH HIDDEN GLASS BEADS
RED QUILTED MINI CAPE IN MATTE JERSEY 100% RAYON
WITH HIDDEN GLASS BEADS

THIS SPREAD:
BILL TURTLE NECK SWEATER IN JERSEY 65% LAMBSWOOL 35% MOHAIR

DaNciNG with the DeaD

Musical Expeditions
DaNciNG with the DeaD
THE MUSIC OF GLOBAL DEATH RITES
CD & Book

6 *Funeral Music* "Funeral Music" Excerpt

Nasioi People of Papua, New Guinea

The tolai orchestra includes twenty-two panpipes divided into four sections of various sizes (from the smallest to the largest: kinne-kinne, kireng, botohi, and nasikolu), two sets of trumpets, kauronta, each comprising five bamboo pipes of different lengths, and five wooden trumpets, called koronn. Several men sing a polyphony.

Says Charles Duvelle. "When I recorded this, they were walking, nearly running, around a tree, but I don't think the tree was sacred, it's just that they were dancing in a circle. The panpipe is really for death; it has spiritual powers. In this particular case, this music is for just after death, maybe a week after."
—Recorded in Buka Island, Bougainville, 1974

Pipers, New Guinea

7 *Eyl Male Rakhamim* "Eyl Male Rakhamim"

God Full of Compassion

Janet Leuchter

Ashkenazic Judaism

The memorial prayer "Eyl Male Rakhamim" is chanted not only for individuals, but for all Jews who have died (depending on the text), both at the funeral service and also at other ritualized memorial occasions. The prayer originally memorialized the Jews massacred during the Crusades (11th–14th centuries) and the Chmielnicky uprisings in the Polish Ukraine (mid-17th century), and it is now sung to memorialize the victims of the Holocaust as well. It has become the emotional climax of the Ashkenazic (European Jewish) prayer services in which it appears. Often the cantor is expected to improvise an artistic, even virtuoso, melodic setting.

• According to the Chamba, who live on the border of Cameroon and Nigeria, the prelanguage vocalizations of babies and the incoherent mouthings of the senile are both seen to originate from the same place; they are the language of the spirit world.

Designers
Clifford Stoltze, Cindy Patten

Art director
Clifford Stoltz

Design company
Stoltze Design

Country of origin
USA

Description of artwork
CD and accompanying hardcover book

Dimensions
5 1/2 x 4 3/4 in
142 x 125 mm

funeral Music

"Funeral Music" Excerpt

Nasioi People of Papua,

⑫ **"Vaishnava Jan Tou**
Tene Khaiye"

Sanjukta Sen

Hinduism in India

Hindus do not have music that is specifically funerary. Vedic texts are chanted or mantras are recited, and

throughout the mourning period, devotional and spiritual songs are sung. This bhajan, or Hindu devotional song, was a favorite of Mahatma Gandhi; it was played at his funeral (and used in the soundtrack of the movie Gandhi), and it is now commonly played to signal the death of a head of state. (A parallel in the

United States would be the song "Amazing Grace," which is now frequently sung and played at funerals.) The lyrics, written by the 15th-century Indian saint Narsi Mehra, are a moving statement of credo.

Lyric Translation

He is the real Vaishnama (saint) who feels others' suffering as his

own. He serves those who are afflicted and has no conceit. He bows before everyone, despises none; is steady in word, body, and mind. Blessed is the mother of such a man. His outlook is always dispassionate, he has left all desires, he sees a mother in another man's wife. He never speaks an untruth, and touches no

A lone figure illuminates the room where many Hindus prepare for their journey in the House of the Dying, in Benares, India.

Music for the End of Mourning

"Music for the End of Mourning" Excerpt

Central African Republic Bokoto Music

This music is performed at the end of the mourning period by two sanza players, one of whom also sings. The sanza is a wooden case with metal strips fixed to it. Metallic rings threaded on the strips make a specific sound. One instrument has ten strips, and the other has twelve. The strips are vibrated with the thumbs and

An apprentice of world renowned African wood carver Kane Kwei stands beside a coffin in Ghana.

monies, processions, and burial and cremation rituals. The sound of this ensemble, which may seem happy and upbeat to Western ears, conjures up a sweet melancholy to the Balinese ear.

"In the same way that some music may seem happy to us, while evoking melancholy to the indigenous listener, emotional expression can often seem mysterious as well. This was brought home to me at the death of a friend in Bali. The daughter of one of our closest musician friends succumbed to leukemia. Her family was torn apart emo-

tionally; she was only in her teens, and she had shown promise of becoming a great gamelan musician. On the evening that she passed away, friends and relatives gathered at her home to talk, play cards, and generally try to maintain a lively atmosphere, to keep the family from sinking further into depression. I saw the girl's father describing to a visitor the progress of the illness and the sequence of events leading to her death. It was not a cheerful story, by any means, but I was struck by his countenance, he related the entire story with a smile on his face and a tear in his eye. I asked a friend sitting next to me how that could be, why was he smiling at such a moment? 'Actually,' the friend said, 'he is in an enviable condition. He has found a perfect balance between happy and sad.'"

— Wayne Vitale, who recorded this track in the Badung district, Banjar Belaran hamlet, village of Kerobokan

Gamelan Angklung

dancing with the dead: CD and book

This collection of death ritual music from around the world sets the designer the tough challenge of imposing a visual identity that serves as a framework for the imagery of diverse cultures. This challenge has been successfully met by adopting a strongly typographic identity based on the titles of the pieces of music included on the CD. This combines well with the culturally specific photographs, producing an engaging package that deals with delicate, even taboo, subject matter.

Designers
Nitesh Mody, Joe Nixon

Art director
Nitesh Mody

Photographers
Joe Lacey, Nitesh Mody,
Joe Nixon

Design company
Moot

Country of origin
UK

Description of artwork
CD cover and booklet

Dimensions
5 1/2 x 4 3/4 in
140 x 123 mm

king louis: CD cover and booklet

Powerful imagery, based on deformed wax casts of the human head – illuminated from within or serving as a screen for projected images – leads the design of this piece. A prominent die cut disc adds a further suggestion of the potential of the human mind. The restrained typography, and the use of a plain sans serif font carries information without competing with the effect of the imagery.

L'avenir de l'Europe.
Parlez, c'est le moment.

La diversité.
L'Europe de toutes les cultures ?

L'élargissement de l'UE.
Combien de place y a-t-il en Europe ?

La Transparence.
Qui fait quoi en Europe ?

ideas for Europe: postcards. website launch: poster and bookmark

Restrained typography serves to clarify the meaning of the clever visual rhetoric employed in all these pieces of work. In the bookmark (below), which advertises the launch of the National Library's website, the symbolism is so clear that the part-opened books actually form part of the published web address.

Bibliothèque nationale online

Catalogue online accessible
24h/24h

Commandes et réservations
online pour lecteurs inscrits
24h/24h

Médiathèque

Accès gratuit à internet

Bibliothèque nationale
Luxembourg
37, Boulevard Roosevelt
L-2450 Luxembourg
Téléphone 22 97 55 - 1
Fax 47 56 72

www.bnl.lu

Designers
Silvano Vidale, Tom
Gloesener

Art directors
Silvano Vidale, Tom
Gloesener

Photographers
Pascal Habousha,
Marcel Strainchamp

Design company
Vidale-Gloesener

Country of origin
Luxembourg

Description of artwork
Postcards for the
Luxembourg Socialist
Party (left). Bookmark
and poster for National
Library website (above)

Dimensions
Various

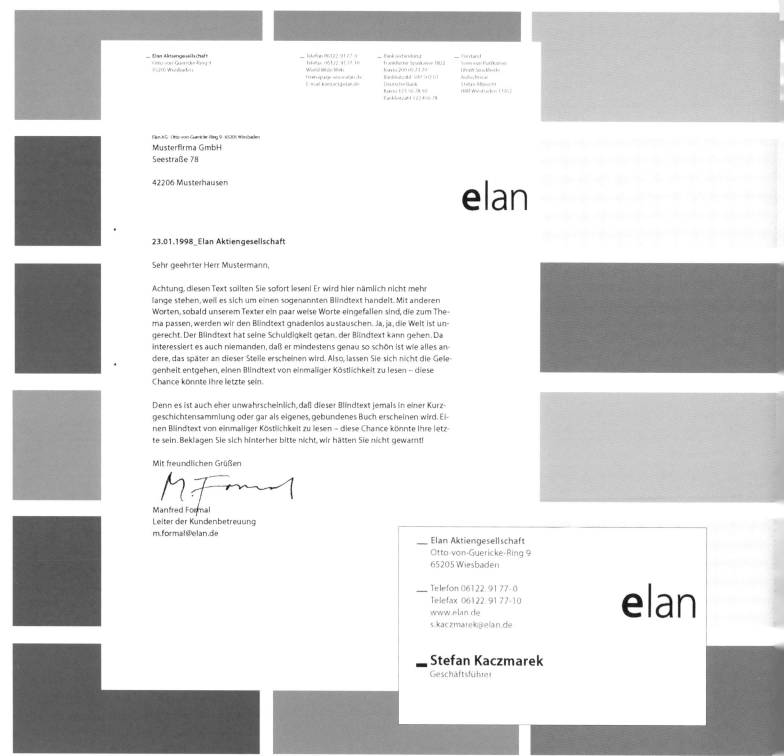

Elan Aktiengesellschaft
Otto-von-Guericke-Ring 9
65205 Wiesbaden

Telefon 06122.91 77-0
Telefax 06122.91 77-10
World Wide Web
Homepage www.elan.de
E-mail kontact@elan.de

Bankverbindung
Frankfurter Sparkasse 1822
Konto 200 05 21 70
Bankleitzahl 500 502 01
Deutsche Bank
Konto 123 56 78 90
Bankleitzahl 123 456 78

Vorstand
Sven von Puttkamer
Ulrich Stockhofe
Aufsichtsrat
Stefan Albrecht
HRB Wiesbaden 11052

Elan AG · Otto-von-Guericke-Ring 9 · 65205 Wiesbaden

Musterfirma GmbH
Seestraße 78

42206 Musterhausen

elan

23.01.1998_Elan Aktiengesellschaft

Sehr geehrter Herr Mustermann,

Achtung, diesen Text sollten Sie sofort lesen! Er wird hier nämlich nicht mehr
lange stehen, weil es sich um einen sogenannten Blindtext handelt. Mit anderen
Worten, sobald unserem Texter ein paar weise Worte eingefallen sind, die zum The-
ma passen, werden wir den Blindtext gnadenlos austauschen. Ja, ja, die Welt ist un-
gerecht. Der Blindtext hat seine Schuldigkeit getan, der Blindtext kann gehen. Da
interessiert es auch niemanden, daß er mindestens genau so schön ist wie alles an-
dere, das später an dieser Stelle erscheinen wird. Also, lassen Sie sich nicht die Gele-
genheit entgehen, einen Blindtext von einmaliger Köstlichkeit zu lesen – diese
Chance könnte Ihre letzte sein.

Denn es ist auch eher unwahrscheinlich, daß dieser Blindtext jemals in einer Kurz-
geschichtensammlung oder gar als eigenes, gebundenes Buch erscheinen wird. Ei-
nen Blindtext von einmaliger Köstlichkeit zu lesen – diese Chance könnte Ihre letz-
te sein. Beklagen Sie sich hinterher bitte nicht, wir hätten Sie nicht gewarnt!

Mit freundlichen Grüßen

Manfred Formal
Leiter der Kundenbetreuung
m.formal@elan.de

Elan Aktiengesellschaft
Otto-von-Guericke-Ring 9
65205 Wiesbaden

Telefon 06122.91 77-0
Telefax 06122.91 77-10
www.elan.de
s.kaczmarek@elan.de

Stefan Kaczmarek
Geschäftsführer

elan

elan: corporate identity

This spread shows design work in progress and finalized
items from the visual identity of internet-based computer
company, elan. The elegant simplicity of the typographic
elements allows great flexibility of color palette and usage.

elan elan elan

elan

elan

Designers
Jochen Merget,
Peter Oehjne

Art director
Peter Oehjne

Design company
Eiche, Oehjne
Design

Country of origin
Germany

**Description of
artwork**
Letterhead (far
left), business
card (left), cards
(above right)

Dimensions
Various

elan elan

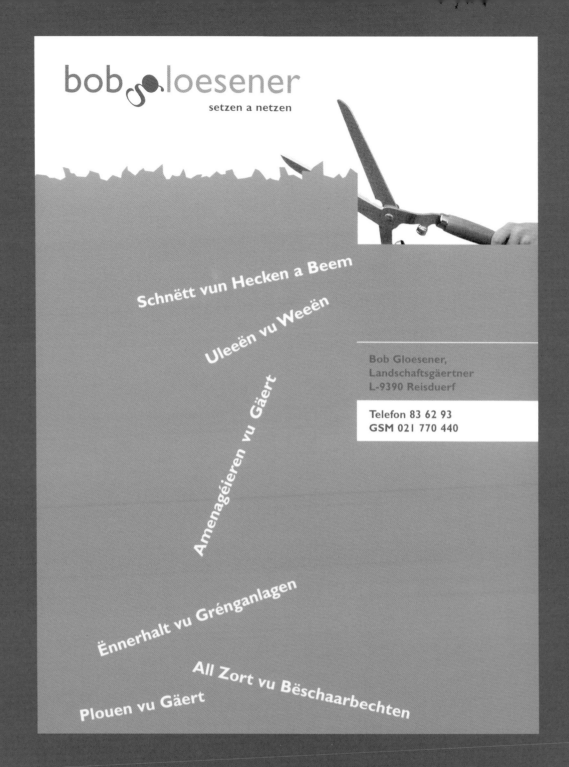

bob loesener

setzen a netzen

Schnëtt vun Hecken a Beem

Uleeën vu Weeën

Amenagéieren vu Gäert

Ënnerhalt vu Grénganlagen

All Zort vu Bëschaarbechten

Plouen vu Gäert

Bob Gloesener,
Landschaftsgäertner
L-9390 Reisduerf

Telefon 83 62 93
GSM 021 770 440

bob loesener

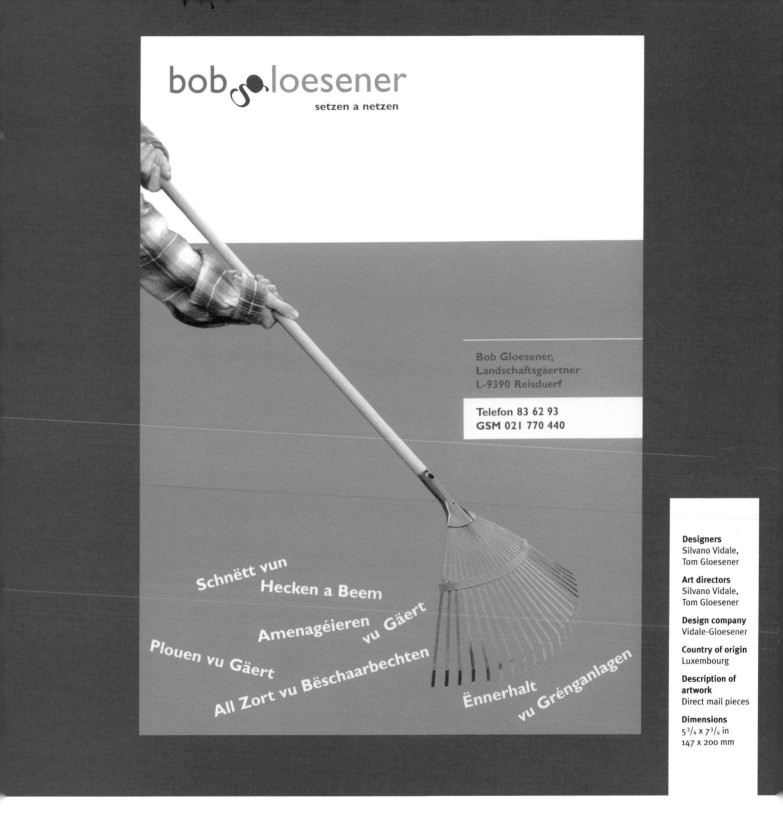

bob gloesener: logo and direct mail campaign
Clever use of visual rhetoric creates high impact direct mail pieces for this gardening company. Mailed in spring (left) and fall (right), the imagery and arrangement of white type on the green background reflects the gardening activities that correspond to the season.

have you found your rabbit today?
rabbit is an indescribable feeling,
a kind of silly happiness that leaves
you dumbfounded for the entire day,
a spontaneous split second that
changes your whole life's events.
rabbit heightens your senses,
presents new perspectives, tempts
you to destroy preconceived
mindsets, challenges you to relearn
your experiences. rabbit redefines
the meaning of your thoughts and
surroundings, re-orientates existing
value systems, and leaves you high.
have you found your rabbit today?

rabbit

FeaturingRabbitWalk ラビットウォーク
TOSHIE TAKEUCHI

Designer
Hanson Ho

Photographer
Toshie Takeuchi

Design company
H55

Country of origin
Singapore

Description of artwork
Poster (far left) and booklet

Dimensions
Poster
16 1/4 x 23 1/4 in
420 x 594 mm
Booklet
4 x 5 3/4 in
104 x 148 mm

Rabbit: self-promotion

Rabbit is the concept behind the prolific self-promotional output of Singaporean design studio H55. The work features mock interviews with animals and pseudo-public information material, presented in what appears to be an authoritative style, using a clear, bold, sans serif face. The cheeky, absurdist approach to self promotion is typified by the substitution of the dot of the "i" with a diminutive rabbit icon. The booklet also serves to promote the work of photographer Toshie Takeuchi.

FamilyAlbum
家族写真

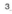

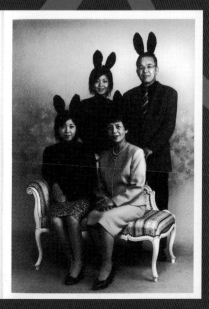

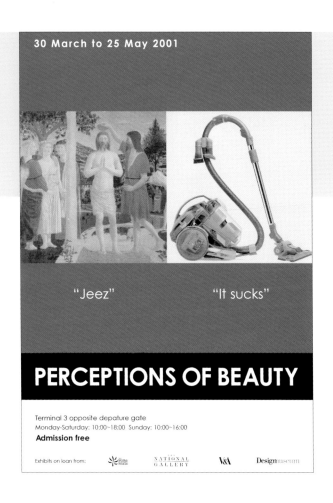

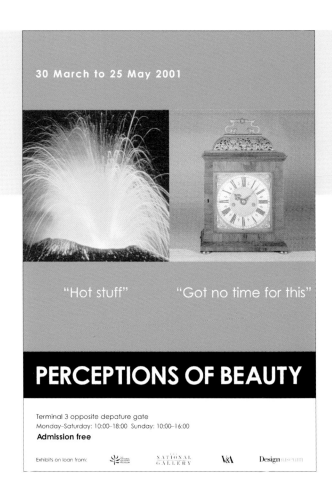

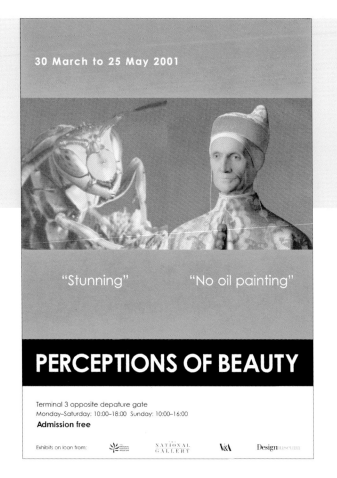

Designer
Yu Shinzawa

Design college
Ravensbourne College of
Design and Communication

Country of Origin
UK

Description of Artwork
Poster series

Dimensions
16$^1/_2$ x 23 in
420 x 594 mm

perceptions of beauty: poster series
The visual rhetoric of this poster series,
produced as part of a student project,
could easily fragment the message, but
the designs gain integrity through their
strength and simplicity. The plain sans
serif type further serves to anchor the
diverse imagery, which suggests the
scope of the advertised exhibition.

30 March to 25 May 2001

"Smashing" "Not my cup of tea"

PERCEPTIONS OF BEAUTY

Terminal 3 opposite depature gate
Monday–Saturday: 10:00–18:00 Sunday: 10:00–16:00
Admission free

Exhibits on loan from: THE NATURAL HISTORY MUSEUM THE NATIONAL GALLERY V&A 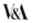 Design museum

Neither life nor art can be brought into being if we consider the spirit alone. Or matter alone. The unity of the two makes creation.

P i e t M o n d r i a n S t r u c t u r e s i n S p a c e M O M A N e w Y o r k 1 s t N o v e m b e r 1 9 4 5

In order to approach the spiritual in art, we will make as little use of possible of reality, because reality is opposed to the spiritual. Hence

there is a logical explanation for elementary forms. As these forms are abstract, we find ourselves in the presence of an abstract art.

colour have found their proper use. From now on, they will be nothing but "plastic" means of expression and will no longer dominate in the work as they did in the past. Neutral line, colour and

s composed by relation and reciprocity. Colour exists only through another colour, dimension is defined by another dimension, there is no position except in opposition to another position. Form and

and in life is the lofty task of our day, it is a way of preparing for the future. Freed of any limitation, plastic art must not only keep pace with human progress, it must even stay ahead of it. Everything

giving birth to a purified plastic expression. Neoplasticism depicts a precise order. It depicts equity, because equivalence in the composition of plastic forms indicates to everyone that equal but none-

The universal can be expressed in pure manner only which the particular does not obstruct our path. Only then can universal consciousness, which is at the origin of all art, be rendered directly,

theless different rights have been assigned. To consider the relationships solely by creating them and attempting to balance them in art

form, have the same brilliant qualities

1 . 0 0 p m - 7 . 0 0 p m $ 2 4

Designers
Phil Jones, Claire Burton,
Mark Smith

Senior lecturers
Tracy Allanson-Smith,
Robert Harland, Leo
Broadley

Art college
University of Derby

Country of origin
UK

Description of artwork
Typographic posters:
Mondrian, Riley,
and Rand

Dimensions
$23^1/_4$ x $36^2/_3$ in
594 x 940 mm

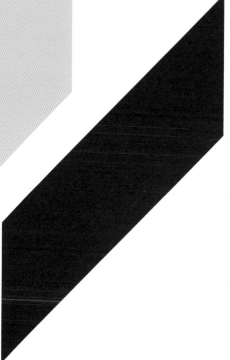

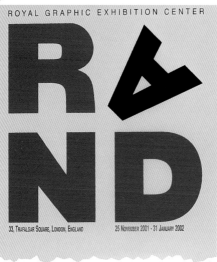

modern art typographic posters
This student work was produced in
response to a difficult brief –
conveying the essence of an artist's
or designer's output through
typography. The Mondrian and Riley
posters successfully and
reverentially pastiche the artists'
work, while the third poster is a
tribute to Rand's perceptive analysis
and ability to evolve deceptively
simple solutions.

THOSE NOT BUSY BEING BORN ARE BUSY DYING.

BOB DYLAN

Designer
Jason Grant

Country of origin
Australia

Description of artwork
Limited edition poster

Dimensions
35¹/₂ x 23¹/₂ in
910 x 650 mm

busy being born: poster

This silk screened self-promotional poster, designed around a quotation from Bob Dylan, could at first sight appear to be a printer's make-ready sheet, with its apparently random collisions of image, color, and text. Subtly layered to make the key words almost invisible, the viewer is forced to work hard to decipher its meaning.

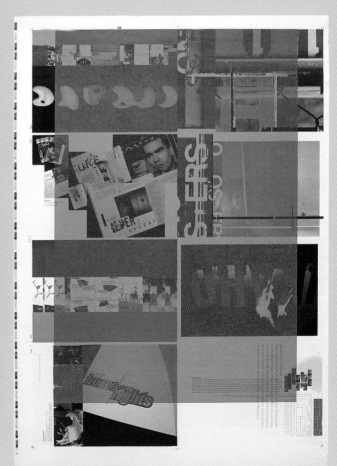

merci

madame,
monsieur

L'Invitation aux Musées
24-25 mars 2001

m
d' stater
museeën

merry x-mas

m
d' stater
museeën

Corporate
Design
Guidelines

Concept

m
d' stater
muséeën

manual

m
d' stater
muséeën

merci

Designers
Silvano Vidale,
Tom Gloesener

Art directors
Silvano Vidale,
Tom Gloesener

Design company
Vidale-Gloesener

Country of origin
Luxembourg

**Description of
artwork**
Corporate identity
and campaigns

Dimensions
Various

d'stater muséeën: identity and campaigns

The essence of the logo design for the
association of museums in Luxembourg City has
been extracted and used as the basis for a series
of mailings and promotional items. The
consistent use of the white "m" with black type
on primary colors reinforces the identity, while
giving the individual pieces instant impact
and visibility. Sophistication is added to the
obvious colors by use of a classic serif typeface.

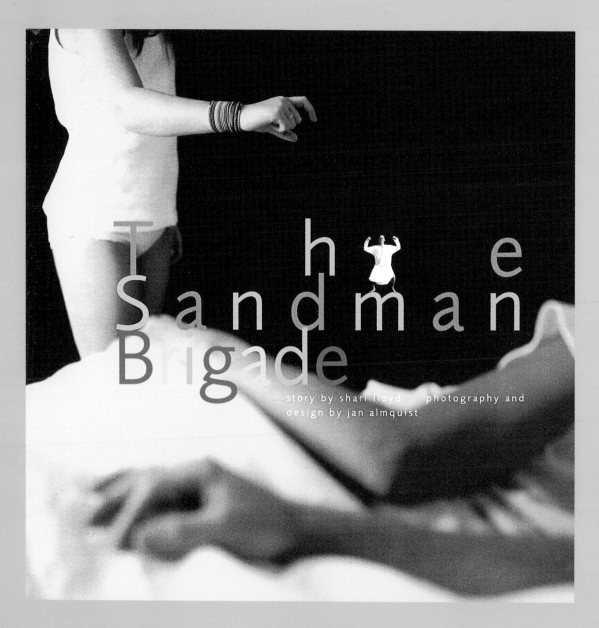

story by shari lloyd photography and
design by jan almquist

the sandman brigade: children's book

The remarkable design of this book adds to the
surreal nature of the story it tells. The use of
monochrome, dreamlike photography gives the
book an ambiguous visual texture that evokes
the stories of Alice in Wonderland. Blocks of
smaller type carry the narrative; these are
interspersed with larger text that creates
atmosphere and instant impact for younger
readers. The voices of characters in the story
are carried by text so tightly leaded that the
ascenders and descenders clash; this helps
convey a barrage of thoughts and emotions.

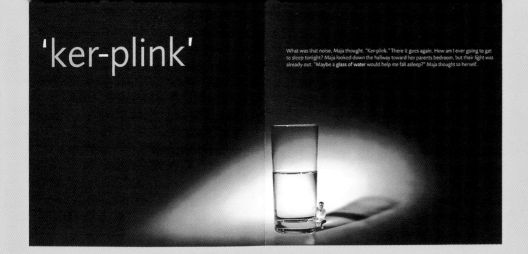

'ker-plink'

What was that noise, Maja thought. "Ker-plink." There it goes again. How am I ever going to get to sleep tonight? Maja looked down the hallway toward her parents bedroom, but their light was already out. "Maybe a glass of water would help me fall asleep?" Maja thought to herself.

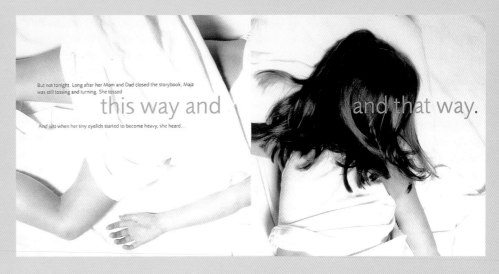

But not tonight. Long after her Mom and Dad closed the storybook, Maja was still tossing and turning. She tossed

this way and

and that way.

And just when her tiny eyelids started to become heavy, she heard...

"I am although people call me the General, and I sprinkle the boogers-ahem, I mean sand, of course-in everyone's eyes.

Designer
Jan Almquist

Art director
Jan Almquist

Photographer
Jan Almquist

Design company
Allemann Almquist & Jones

Country of origin
USA

Description of artwork
Photographic children's book

Dimensions
$8^{1}/_{2}$ x $8^{1}/_{2}$ in
216 x 216 mm

"Step right up, Maja, and meet Geza M. He sprinkles bad-breath dust in everyone's mouth."

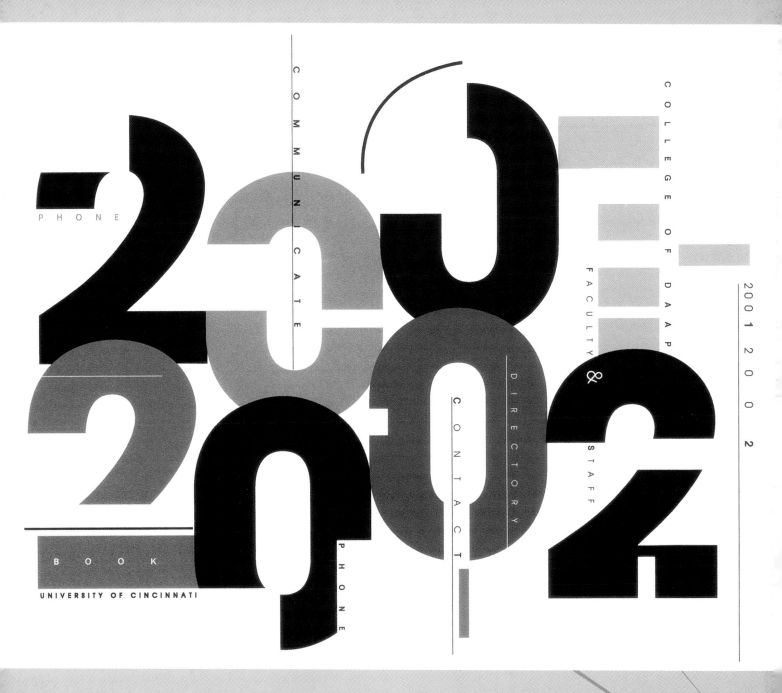

PHONE

COMMUNICATE

COLLEGE OF DAAP

FACULTY

DIRECTORY

CONTACT

STAFF

PHONE

2001 2 0 0 2

2002

2002

BOOK

UNIVERSITY OF CINCINNATI

cover design and holiday cards

These four pieces are examples of effective figure-and-ground composition, in which the negative space assumes the same importance as the positive. The design above, for a university staff directory, abstracts the bold shapes of a sans serif face to create a geometric pattern, subtly printed in black and three solid grey inks. The first two of the three Holiday cards (opposite) are based on Hebrew calligraphy: in the first, positive space leads the composition; in the second, negative space dominates. The third card features an abstract illustration of a ram's horn (blown to announce the Jewish New Year), which adds to the impact of the surrounding letterforms.

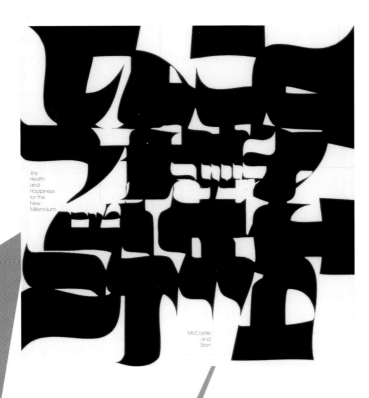

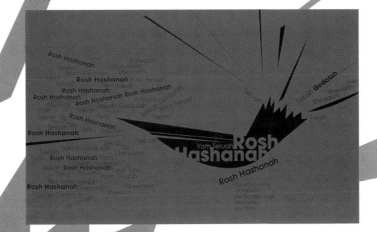

Designer
Stan Brod

Art director
Stan Brod

Design company
Wood/Brod design

Country of origin
USA

Description of artwork
Cover design for staff directory (far left), and three Holiday cards for the Jewish New Year

Dimensions
Various

Designers
Silvano Vidale,
Tom Gloesener

Art directors
Silvano Vidale,
Tom Gloesener

Design company
Vidale-Gloesener

Country of origin
Luxembourg

Description of artwork
Weekly
independent
newspaper

Dimensions
12¹/₂ x 17¹/₄ in
317 x 440 mm

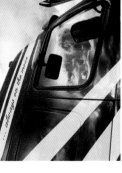

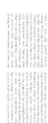

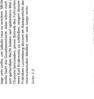

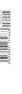

+++voll_cool!+++

Attacke auf den Tag des Herrn

Per Richtlinie soll EU-weit der Arbeitszeit für
Lkw- und Busfahrer harmonisiert werden.
Mit potenziell folgenschweren Flexibilitäts-
klauseln.

d'Lëtzebuerger **Land**

Bock zum Gärtner ?

d'Lëtzebuerger Land: newspaper

This clean design, based upon a five-column grid, allows for great
variety and flexibility in page layout. A single sans serif face holds all
the headlines, and one serif face is used for almost all the editorial
text to maximize clarity and ease of navigation. Unusually for a
newspaper, the designers make liberal and effective use of white
space, with the result that spread design is sometimes closer to that
seen in magazines.

Kaum hat das Ausland Kenntnis vom Montebourg-Bericht genommen, steht Luxemburg als Zentrum der Lkw-Sklaverei da

Jetzt kommt der Trucker-Tisch

Peter Feist

Wie Karl Kralowetz seine Betriebe organisiert hat, scheint dem Luxemburger Niederlassungsrecht zu entsprechen

Auch nach dem geltenden Niederlassungsrecht hätte spätestens seit Sommer 2001 die Chance bestanden, Kralowetz' Betrieb zu schließen

The University of Cincinnati's

College of

Design

Architecture

Art

Planning

Visions ƧnoiƨiVɘЯ

sion, and
of Cincinnati

society, and to
place and
ual arts in the
unity.

ION ST

with a history of DAAP

33,747

total student population at the University of Cincinnati

The University of Cincinnati was the first university to have a program of cooperative education, which began in 1906. The University also offered the nation's first bachelor's degree program in nursing.

During the 1998-1999 academic year, there were 17,833 full-time undergraduate students, 4,422 full-time graduate and professional students, 8,348 part-time undergraduate students, and 3,144 part-time graduate and professional students.

UC includes a main academic campus often called 'West Campus,' a medical campus known as 'East Campus,' a branch campus in suburban Blue Ash, and a rural branch campus in Clermont County just east of Cincinnati.

89%

Approximately 89% of the University's total enrollment are residents of Ohio.

17,708

52.5% 4,422 8,348

3,144 23

Women constitute 52.5% (17,708) of UC's student population, and men 47.5% (16,039). The College of Design, Architecture, Art, and Planning had an undergraduate enrollment of 1,635. Women constitute 49.7% (813) of DAAP's student population, and men 50.3% (822).

The Architecture and Interior Design programs were ranked third and first respectively by *The Almanac of Architecture and Design 2000*.

Dr. Albert Sabin developed the first oral polio vaccine at the University of Cincinnati.

The average age of full-time students is 23 years old. The average age of part-time students is 32.

THE McMICKEN SCHOOL OF DESIGN

The University of Cincinnati's McMicken School of Design was to serve as a center of training, teaching and exhibitions for Cincinnati's art world for the next 15 years, with several of its programs gaining national recognition, bringing a new prominence to the decorative arts across the nation. Among the painters trained at the McMicken School, many achieved wide recognition, including John H. Twachtman, Elizabeth Nourse, Robert Blum,

Edward H. Potthast and Joseph R. DeCamp. The School's role in the revival of the handicrafts, especially woodcarving and ceramics, was widely acclaimed. Although the McMicken School of Design eventually was subsumed by the new Cincinnati Art Academy (whose graduates quite correctly trace their school's own lineage to the McMicken School), it established during its years within the McMicken University/University of Cincinnati system

a history of success in arts training that would be revived and expanded in the early twentieth century. The history of this shared ancestor reveals a commitment to a unique approach to arts education that is still evident at DAAP today.

The University of Cincinnati's first school of design traced its background to the untiring efforts of Sarah Worthington King Peter, a Cincinnatian who earlier had founded the Ladies' Academy of Fine Arts in Philadelphia and who was dedicated to promoting women's arts education. In her efforts during the 1850s to attract supporters and funding for her educational projects in Cincinnati, Peter utilized arguments that would be repeated often over the next quarter century: manufacturing success must be linked to proper design if American wares were to compete and

win in the international marketplace. For Peter, women possessed unique qualities and talents which made them especially suitable as designers. Local manufacturers who would support a school of design, she argued, would find their efforts repaid tenfold in terms of the improved quality and appeal of their well-designed products, especially in furniture and pottery. In 1854, she founded the Ladies' Academy of Fine Arts whose operations ceased with the disruptions of the Civil War. In 1864, its board of directors donated the Academy's collection of statuary and oil paintings to the McMicken University. There it eventually formed the core of a new fine arts program (the new university's first functioning department) known as the School of Drawing and Design of the McMicken University, later called 'the most important practical

1843
McMicken Hall constructed

1845
Fire and destruction of Cincinnati College in January

1846
Cincinnati College rebuilt in stone, with a plan by Henry Walter

visions/revisions: college review
(see also pp. 132–135)

A carefully measured layout allows this single college publication to serve three distinct purposes: an overview of current activity (top two-thirds of the spread); a listing of alumni (band of vertical type); and a history of the college itself, with significant dates highlighted in the margin (foot of page). Consistent use of the page area allows the publication to be read from cover to cover in three different ways, and avoids the jumble of information that characterizes many multipurpose reports and annual reviews. Counter to expectation, the use of a very rigid page structure actually gives the designer greater freedom to exploit the top two-thirds of each spread in diverse ways.

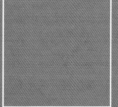
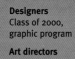

Designers
Class of 2000, graphic program

Art directors
Robert Probst, Stan Brod, Patrick Schreiber, Joe Bottoni

Photographers
Jeff Goldberg/Esto, Maureen France, and the graphic design students

Design college
College of design, architecture, art, and planning, University of Cincinnati

Country of origin
USA

Description of artwork
College portfolio

Dimensions
10 x 15 in
254 x 381 mm

The **University of Cincinnati**
traces its origins to
1819

the year of the founding of the Cincinnati College
and the Medical College of Ohio.

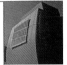

In 1870, the City of Cincinnati established the University of Cincinnati, which later absorbed the earlier institutions. In 1906, the University of Cincinnati created the first cooperative education program in the United States through its College of Engineering. For many years, the University of Cincinnati was the second-oldest and second-largest municipal university in the country. In 1968, UC became a municipally-sponsored, state-affiliated institution, entering a transitional period culminating on July 1, 1977 when UC became one of Ohio's state universities. Today, the University of Cincinnati is one of only 88 universities classified as Research 1 by the Carnegie Commission.

1843
University
erected

relationship to industry with the inclusion of substantial art exhibition in most of the major expositions by 1872.

Why would Cincinnati dedicate itself to such a pragmatic approach to the arts? Certainly there were artists and collectors who had little interest in applying art to machine-made products (although many artists often turned to such work to make ends meet). There was, as well, a dedicated group of artisans in the city who responded to the emergence of what William Morris termed the Age of Shoddy by fostering a revival of the handicrafts. They too were concerned with celebrating the relationship of design and function but apart from (rather than applied to) industrial production. However, for many of the city's arts patrons, most of whom were intimately tied to the industrial and commercial life...

...tic of the city, the wedding of art to industry made great sense. Although Cincinnati's manufacturing and commercial productivity remained strong, it had declined relative to other cities, especially Chicago. Competition was felt not only between cities vying for top rankings in the race for commercial/industrial preeminence, as a nation. America was viewed increasingly as second-rate in its ability to produce quality manufactured goods. Across the nation and beyond, civic and industrial leaders as well as arts patrons and educators began to urge application of the arts to industry. Cincinnati, as the major art center of the Midwest, experienced sentiments heard as well in Boston, New York and Philadelphia. The future, as they saw it, lay in the successful union of artistic design (and execution) to the processes and products of industry.

By mid-century in Cincinnati, education in the arts was already reflecting this pragmatic approach. The Ohio Mechanics Institute (OMI), established in 1828, was originally intended, through its classes, to promote the 'cultivation of arts and sciences' with a concentration on the fine arts. However, by the 1850s, OMI's School of Design gradually began to stress the 'practical arts' in its curriculum, an emphasis that would predominate at OMI in future years. Although the OMI teaching staff included Frank Duveneck, who helped guide the work of many important regional artists, the school remained tied to its artisan roots and to the training of craftsmen, draftsmen and others intent on applying their skills to the products of manufacturing. OMI's role in the promotion of industrial expositions, for example, reveals the latitude and flexibility such schools maintained in endorsing both the fine and industrial arts. It was within this setting of civic optimism and cultural ferment that the forerunner of DAAP opened its doors in 1869.

The future, as they saw it, lay in the successful union of artistic design (and execution) to the processes and products of industry.

Graphic Design deals with design for communication. Graphic designers are able to analyze communication problems and needs and to visualize messages, ideas, and feelings in concise, effective and visually satisfying ways.

The purpose of graphic design may be to inform, identify, clarify, or persuade the public or a specific audience. The finished design usually combines a drawn or photographic image with a headline and typography. Most often the work is reproduced through the printing process, but it may take other forms such as presentation, a film, a slide presentation or a package. The tools are often a brush or a computer.

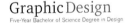

Graphic Design
Five-Year Bachelor of Science Degree in Design

'We do not want the students to approach a project with a very specific way of thinking, but rather with an open mind for problem solving in an ever-changing society.'

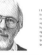

I think there is a very clear distinction between training students and teaching students. Training means that you make someone do something repeatedly until they are able to do it without having to think about it. Education is exactly the opposite of that. We do not want the students to approach a project with a very specific way of thinking, but rather with an open mind for problem solving in an ever-changing society.

The most important thing for a student to take away from this program is an understanding of the purpose of graphic design. Our basic task as graphic designers is to visually communicate from one group of people to another, and to do it most effectively. The designer's responsibility is to visually communicate, to inform, to instruct but also to enlighten the audience.

FACULTY PROFILE: HEINZ SCHENKER
Associate Professor of Graphic Design

Heinz Schenker is a graduate of the School of Design in Basel, Switzerland. After four years of working as a graphic designer in Paris, France he held an art director position in Geneva, Switzerland. He has been a full time faculty at the University of Cincinnati since 1989. Mr. Schenker's design work is featured in many national and international publications and he has received numerous awards from professional organizations.

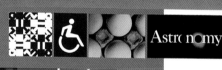

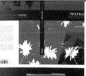

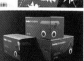

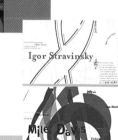

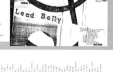

MICHAEL BEEBE
GRAPHIC DESIGN STUDENT
Music Poster Series, Fourth Year

An aspect of my education that I value is my relationship with the professors. I value learning from people who have worked in the profession, have studied design intensely, and who come from different backgrounds. I have enjoyed and benefited from listening and absorbing as much as possible from them.

acclaim. What ensued was a debate over modernism versus Beaux-Arts that would embroil architects, educators and arts administrators for the next decade and beyond. Many of the nation's best-known schools took an early stand in the debate. Harvard University attracted Walter Gropius to its campus in 1937 to reinvigorate its architectural program. In 1938, Ludwig Mies van der Rohe came to Chicago's Armour (later Illinois) Institute of Technology which had a larger enrollment than any other urban architectural school in the country. The modern movement had its stars and the stars found their firmament within schools of architecture in depression America.

The University of Cincinnati's Department of Architecture was not a showcase for stars. Yet the work of architectural training...

...at UC continued and in many ways paralleled the course taken at the Bauhaus and the New (American) Bauhaus. Since its inception, the School of Applied Arts, like its predecessor, the McMicken School of Design, was dedicated to the uniting of art and technology. Like Mies' program at Chicago, UC's architectural program included a comprehensive background followed by advanced, hands-on work during a student's final years. Mastery of drawing was considered paramount in both Cincinnati and Chicago. Mies was dedicated to architectural education as 'an organic unfolding of spiritual and cultural relationships.' (Mies van der Rohe: Architect as Educator). Schenker's strong three-year humanities program provided both context and material for making cultural/historical relationships. Ultimately, of course, much...

...separated the two educator/architects. Mies was a philosopher, an artist and an educator whose modernist vision never wavered. Schenker was a pragmatist whose talents, while nationally known within the cooperative education movement, remained sharply directed toward the training and instruction of skilled and employable engineers, architects and designers.

The debate over modernism continued at UC long after it had been resolved at Chicago. In the first Applied Arts Annual, published in 1930, students were eager to connect their work at the School of Applied Arts to the 'great art of the classical past. This emphasis was reinforced by the program's collaboration with the Beaux Arts Institute of Design (BAID) in New York whose monthly competitions provided a classically based standard for designs and renderings. The long-established influence of the BAID seemed especially vulnerable with the advent of modernism.

By 1934, Applied Arts students viewed themselves as a 'transitional age' in which they sought to balance the impact of this wholesome revolt' [modernism] with the values and techniques of inherited tradition. Fifth-year students of architecture believed they had witnessed enormous change during their five years in the program. As first-year students, much of their work had been executed...

UC's architectural training in many ways paralleled the course taken at the Bauhaus and the New (American) Bauhaus.

132

School of Architecture and Interior Design

PLANNING

'Planning is the 21st century profession, and the University of Cincinnati School of **PLANNING** is the 21st century planning school'. –David Edelman, Director, School of Planning

The challenge posed by the urban world is the substance of the planning profession. Planners are dedicated to managing cities and planning for their development in innovative ways. The constructive management of change and communities, but their concerns are issues that affect the world – land use, social policy, historic preservation, transportation, housing, economic development, policy planning, environmental protection, urban design and international development. Planners are visionaries working for a better future. They create this future through improvements in the quality of life in one or more of these areas.

The School of Planning

19 Full-time faculty + adjuncts
150 Undergraduate Students
50 Graduate Students

The studio-based, five-year Bachelor of Urban Planning program, with its required six quarters of co-op and student-owned computers, is one of the best undergraduate programs in the nation. It is the objective of the school to reach this level overall, and this is within reach. With the new Master of Community Planning for mid-career professionals, its future PhD program and the proposed Center for Urban Imaging, the school will be at the leading edge in the further development of the profession.

Jay Chatterjee: Building Excellence

With Bertram Berenson away on his final leave of absence, Jay Chatterjee from the School of Planning served as acting dean. During this period, Chatterjee demonstrated the quiet strength and discipline necessary to calm opposing factions within the college. As a sense of stability returned, Chatterjee was asked to assume the post permanently. In the years since 1982, Dean Chatterjee has endeavored to promote an environment of peace and harmony within DAAP while at the same time providing support and direction to students and faculty.

Educated abroad, Jay Chatterjee earned a Bachelor of Architecture (Honors) from the Indian Institute of Technology in 1958 followed by a Certificate in Tropical Housing from the Architectural Association in London, England in 1959. After Chatterjee came to the United States his education continued and he earned a Master of Regional Planning from the University of North Carolina in 1962. A Master of Architecture in Urban Design from Harvard University followed in 1965. Coming to DAAP in 1967 from Harvard, Chatterjee knew the college well by the time he assumed the deanship. Having served as director of the School of Planning since 1977 and as associate dean under Berenson, he understood that administering DAAP required skills beyond those of a peacemaker and stabilizer. The college's future, he recognized, would be tied to achieving a synthesis between the technical and humanistic disciplines, both of which were well represented at DAAP. Under Chatterjee, the age-old struggle between the fine and applied arts would be reinterpreted, recharged, and redirected to reflect a broader view of visual arts education and its function. Nonetheless, Chatterjee's vision was consistent with that of his predecessors: to produce technically proficient graduates imbued with a high degree of cultural and aesthetic sensitivity whose work would be self-satisfying while serving the larger society. It was a notion as familiar to Herman Schneider as to Jay Chatterjee. While the emphasis may have fluctuated over the years, all DAAP's leaders understood the importance of achieving a balance between the technical (or 'applied') and the humanistic (or 'fine') arts disciplines. This dynamic tension reflects how the institution has changed throughout the years. According to Dean Chatterjee, 'there is more emphasis on history and scholarship than there used to be. We have taken a program that was craft-oriented and added more substantive work on the underpinning of the disciplines' (DAAP 1998 Alumni Directory, Interview with Dean Chatterjee, p. 1). This relationship has been further nourished by the

Mission Statement:

The University of Cincinnati is a public comprehensive system of learning and research. The excellent faculty have distinguished themselves world-wide for their **creative pedagogy** and research especially in problem solving and the application of their discoveries.

The University system is designed to serve a **diverse** student body with a broad range of interests and goals. It is a place of **opportunity**.

In support of this mission, the **University of Cincinnati** strives to provide the highest quality learning environment, world-renowned scholarship, innovation and community service, and to serve as a place where freedom of intellectual interchange flourishes.

THE MAKING OF AN INSTITUTION

1819

ACADEMIC PROGRAMS

Over 33,000 students from 50 states and 95 countries studying in more than 500 academic programs, all at **one university.**

1870

1871

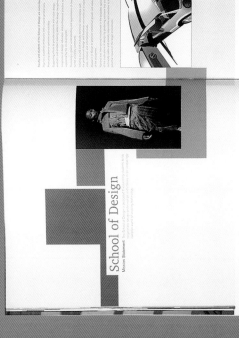

School of Design

Mission Statement

1927

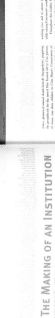

VISION

Coursework in Art in industry quickly developed into a large and successful area of study, predecessor to today's industrial design program.

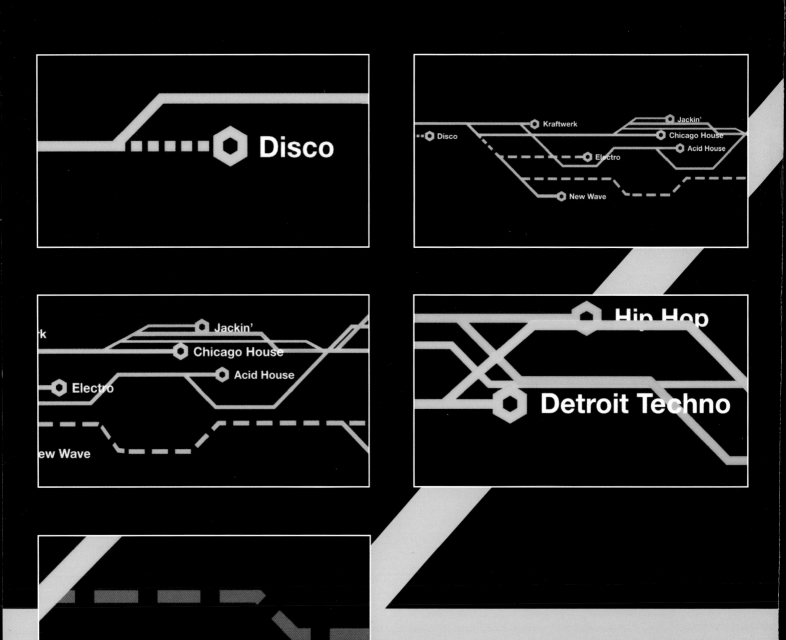

Disco

Kraftwerk
Jackin'
Chicago House
Electro
Acid House
New Wave

Jackin'
Chicago House
Acid House
Electro
New Wave

Hip Hop
Detroit Techno

Hardcore

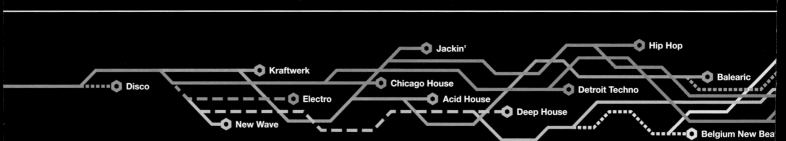

Jackin'
Hip Hop
Kraftwerk
Disco
Chicago House
Balearic
Electro
Acid House
Detroit Techno
Deep House
New Wave
Belgium New Beat

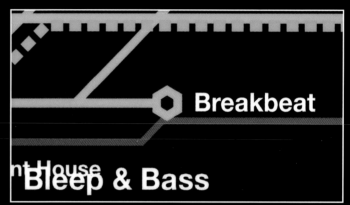

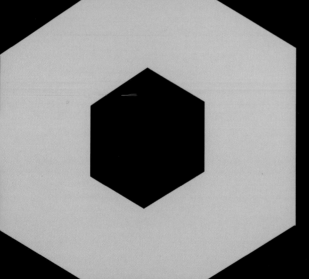

pump up the volume: tv title sequence
(see also pp. 138–139)

The designs formed the basis for a title sequence used in a television documentary charting the development of house music. Based on the distinctive graphics of a subway map, they set out the evolution of the music in its uncompromisingly urban setting, with each genre and subgenre a named subway destination.

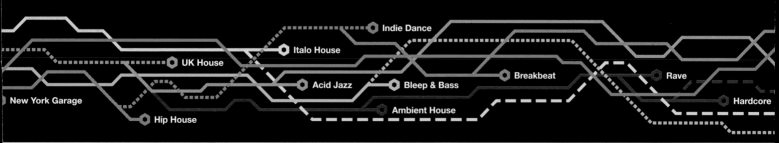

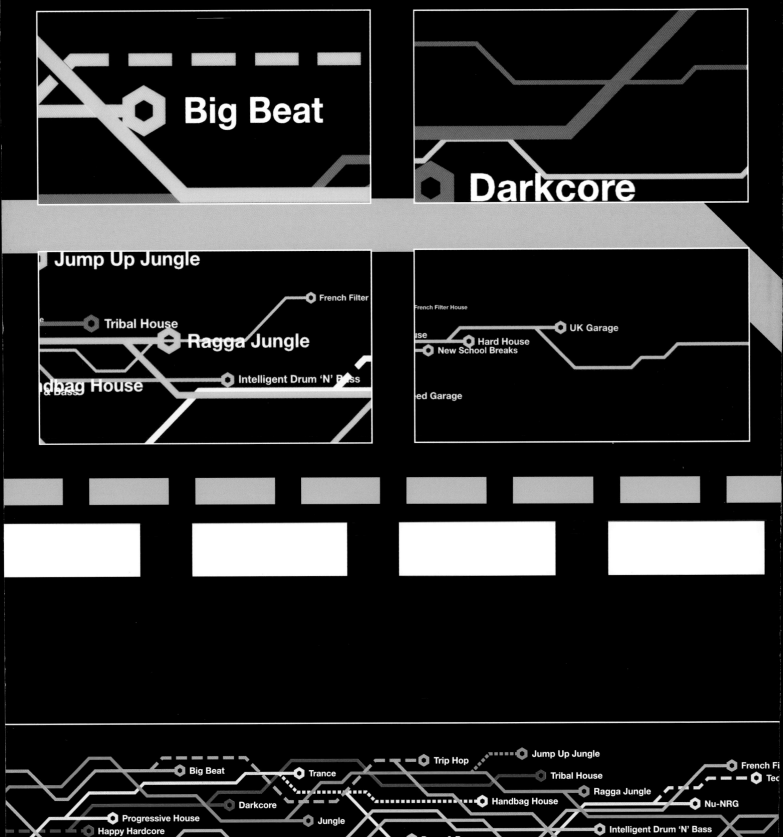

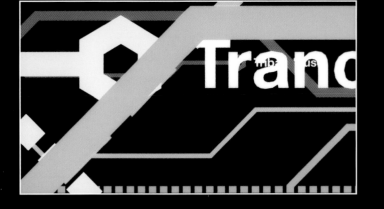

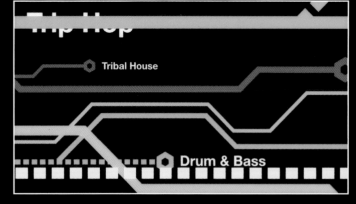

Trance

Trip Hop

Tribal House

Drum & Bass

Pump Up
The Volume

Designers
Neil Bowen,
Caroline Moorhouse

Art directors
Neil Bowen, Mark
Logue

**3D graphics and
post production**
Rob Rae

Design company
Zip Design and
Punk films

Country of origin
UK

**Description of
artwork**
Title sequence for
TV programme

Dimensions
TV format

House
ouse

Hard House

New School Breaks

UK Garage

Speed Garage

Pump Up
The Volume

History Of
House Music

Time To Jack

INDEX

GLOSSARY

of useful terms

ARTWORK
Any original prepared for reproduction by manual, electronic, or mechanical means.

ASCENDER
The part of a lower case letter (such as h, k, and l) that rises above the **x-height**.

BASELINE
An imaginary horizontal line along which the bottom of capital letters, and most lower case letters, align.

BLEED
The printed area outside the **trim marks** on a page. Bleed printing achieves a clean edge where color is run to the borders of a page.

BODY TYPE
A **typeface**, usually less than 14 **point** in size, used to set the main text in a book or magazine.

CAP HEIGHT
The measurement from the **baseline** to the top of a capital letter.

CHARACTER
A letter (upper or lower case), number, punctuation or other mark, which forms part of a **font**.

DESCENDER
The part of a lower case letter (such as g, j, and y) that dips below the **x-height**.

DIE CUTTING
A **letterpress** process that uses a die made of sharpened steel that can cut or perforate paper in almost any shape.

DUOTONE
A **halftone** that prints in two colors to create greater visual interest or to hold detail in a photograph.

FOLIO
The page number in a book.

FONT
A set of characters with a unique appearance in a distinctive style. Also sometimes known as fount.

HALFTONE
Image broken down into dots so fine that they cannot be seen with the naked eye, thus giving the impression of a continuous tone image, such as a photograph.

LEADING
The amount of space, measured from **baseline** to baseline, beween two or more lines of type.

LETTERPRESS
Any printing process where ink is applied to a raised image and pressed on to paper. Years ago, this was the most common form of printing, until it was largely supplanted by **lithography**.

LAYOUT
The arrangement of text and graphics on a page.

LITHOGRAPHY
A method of printing in which ink is transferred from a chemically treated flat **plate** to paper.

MAKE-READY SHEETS
Sheets of paper used by a printer when preparing a press for use. Typically, waste sheets from previous jobs are passed through the press to absorb excess ink before the "live" job is run.

PIXEL
The basic unit that makes up an image viewed on a TV or computer monitor. The ultimate size of an electronic image when viewed on a screen depends on its dimensions in pixels and the resolution of the screen.

PLATE
Thin metal sheet that carries the detail of all text and **halftones** to be printed. The plate is fixed into place on a **lithography** printing press: ink applied to the plate sticks to the image areas and is repelled from non-image areas.

POINT SIZE
In **typography**, still the most common unit of measurement used to denote the size of a typeface. There are approximately 72 points to one inch.

SANS SERIF
See **serif**.

SERIF
In **typography**, a serif **typeface** is characterized by additional strokes at the extremities of each character. A typeface that lacks this is referred to as sans serif. Baskerville is an example of a serif face; Univers is a sans-serif face.

SILK SCREEN
A method of printing in which ink is forced through a mesh made from fine material (originally silk) on to the surface to be printed.

TRIM MARKS
Cutting guides marked outside the intended print area that set the final size to which the paper will be cut.

TYPEFACE
The style or design of the type.

TYPOGRAPHY
The art of selecting and using **fonts**.

X-HEIGHT
The measurement from the **baseline** to the top of a lower case letter.

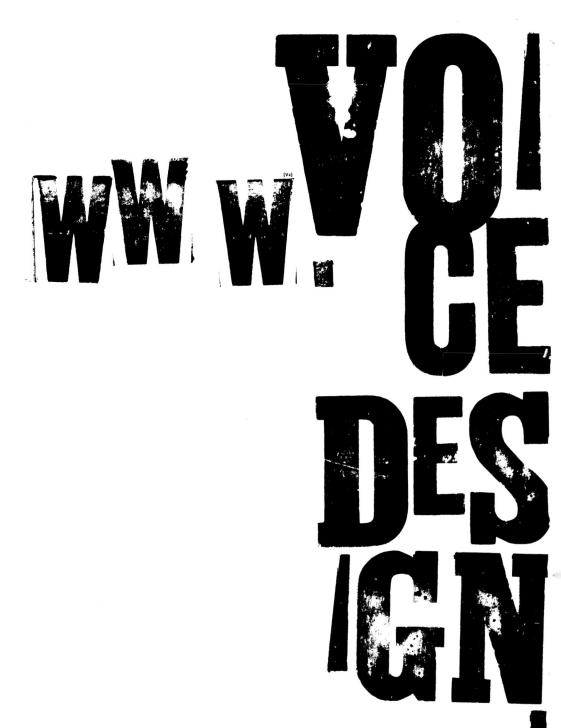

WWW.VOICE DESIGN .NET

www.voicedesign.net -> Proudly Sponsored by Tomasetti Paper House © Finsbury Printing. Printed on Saxton Smooth Chardonnay 140gsm

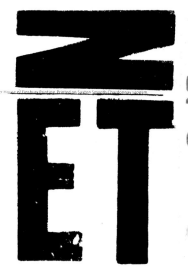

Designers
Scott Carslake,
Anthony De Leo

Design company
Voice

Country of origin
Australia

**Description of
artwork**
Wood-block
typeset poster

Dimensions
16¹/₂ x 23 in
594 x 420 mm

LIVE BIG